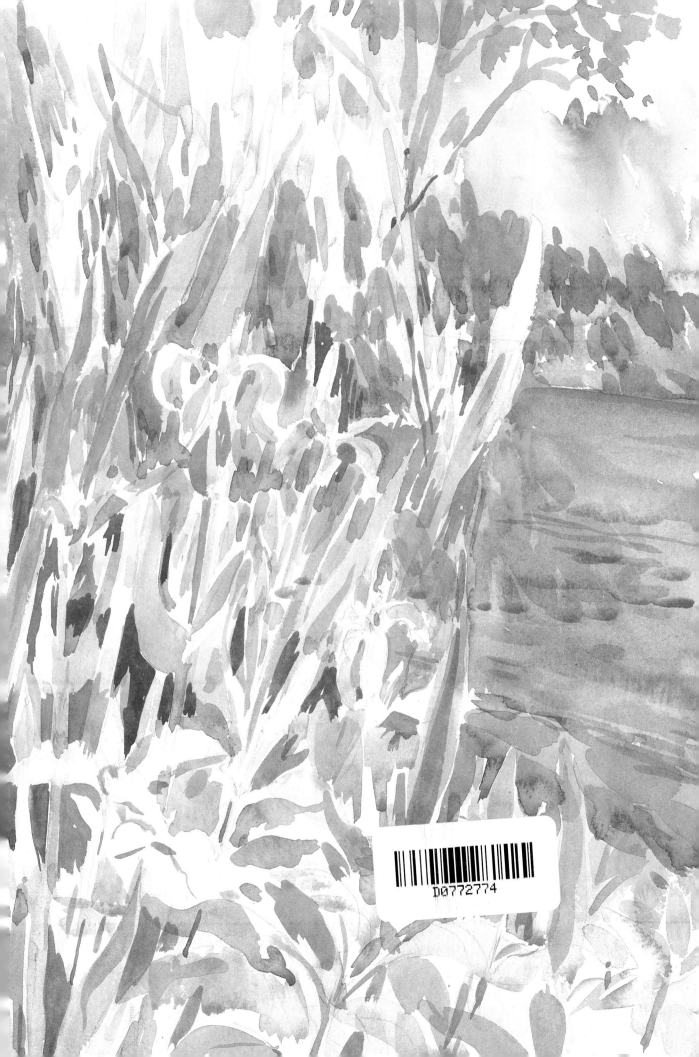

Flowers in the
Landscape

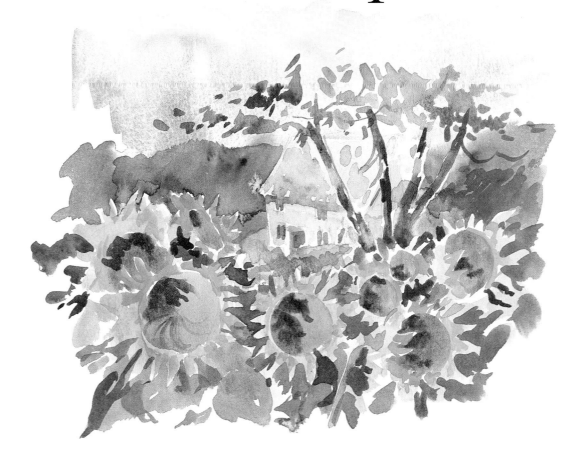

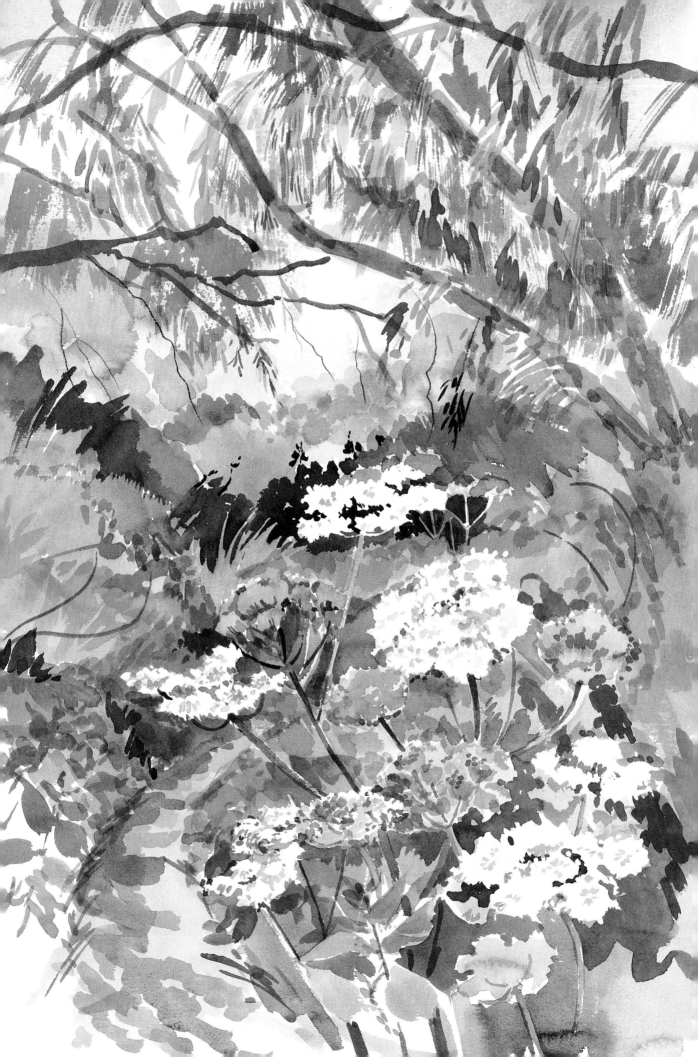

Contents

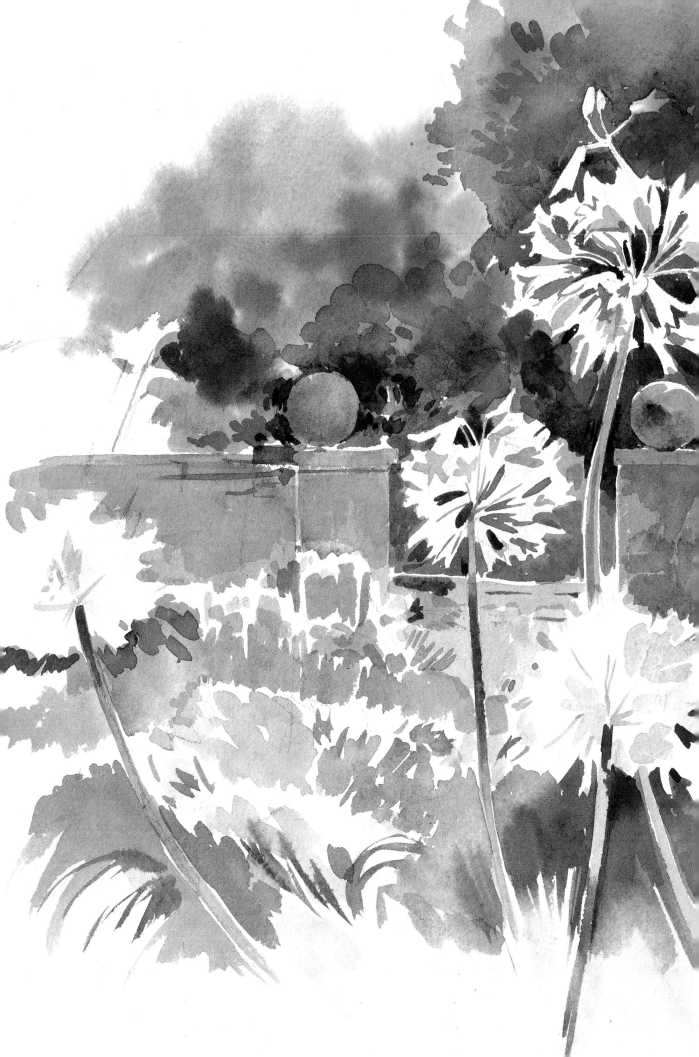

Introduction

There is no doubt that painting is a delightful occupation, even if at times it is a frustrating one. It can certainly look easier than it is, and on occasion appears to become harder the more you know! Sometimes we see a particular view or composition and would love to be able to put it down on paper in a convincing way. It could be the light that is the attraction, or a particular colour combination; whatever it is, the idea of painting the subject is irresistible – but good results don't just happen. Of course, very occasionally something may occur quite by chance which works, but this happens very rarely! Besides, we all have preconceived ideas regarding the kind of painting we would like to be able to produce. For instance we all like to look at flowers; we may not recognize them by their particular names, but we appreciate their beauty and colour, and their variety of shape – these being some of the reasons why artists have loved to paint them throughout the ages. Painting flowers encompasses the many varieties, the infinitely various types of leaves, the multitude of colours and all the different tints, shades and hues.

It is easy, or comparatively easy, to put flowers in a vase and try to paint them, but to be able to paint them in the situation in which they grow is something quite different. For this the artist has to know how to draw, compose and efficiently portray the subject in its surroundings whether a landscape, an interior or a garden. The project could be to paint lilies in a garden, wild roses in a hedgerow or thistles in a field. You could be looking through a gap in a hedge so as to perceive the landscape beyond, or you might see a house appearing through trees and vegetation. There are subjects to paint everywhere, and we don't have to be especially gifted to recognize them. Some artists love to paint boats, or animals, or street scenes; for myself, nature is my inspiration.

In open rolling countryside the sweep of the fields, and the distant hills and trees are compelling to the eye, and the breadth and spread of the country is impressive; but often the landscape that the on-looker appreciates most readily is the more intimate one, with which he feels more closely connected. Thus hedges, gates, trees and vegetation are all closer to the eye and more easily encompassed, as are situations which are framed by the branches of trees or seen through tall waving grass. Many of us live in cities and towns where distant views are almost non-existent, where the eye experiences scenes which are necessarily dictated by the immediate environment.

Landscape painters quite often long for colour other than green, and will be found travelling all over the world in their quest for colourful subjects; flower painters, too, are seen searching for that extra something which they believe will revitalize their work. In art we can make use of the many ideas that combining flowers and landscapes can give us: we can use flowers in close-ups or in the distance, we can vary the season, add atmosphere and mood; in fact we can enlarge our repertoire considerably and as artists become more complete.

Starting with Confidence

Preparation

We will start in small ways, by enlarging your memory and your techniques. In an ideal world an unlimited amount of time could be spent in preparing, and in some ways most paintings are preparations for the next. However, by 'preparation' I really have in mind studies of various sorts: drawings in pencil or brush, and colour studies in sketch-books, all the time building upon ideas, not only improving your drawing skills but enlarging your personal reference library.

When painting landscape it is often easy to lose sight of the main objective. There is usually a particular idea which attracts you in the first instance: it could be any one of a number of things – colour, pattern, light – but when you are transferring the image, the original concept can get lost, so if possible make a small sketch which enhances your first impressions. So often one starts out full of enthusiasm, only to be disappointed on finishing, so try to keep the main idea foremost in your mind.

Describing in watercolour the landscape in front of your subject must, of necessity, be a fairly rapid exercise. You are at the mercy of weather and time and your own painting limitations, and so your preparation work is of vital importance. It is almost like taking an exam – it is the culmination of study.

This does, of course, presuppose that you have some experience of sketching, and that when out in the countryside you have some idea of how to start. When confronted with a general, pleasant scene, can you compose and find your picture area? Most beginners tackle too much, and in fact the simplest doorway or a few flower-pots can be enough. Using a viewfinder (a simple rectangular window cut in a piece of card) will help you decide your painting area, and together with sketches, can be very useful. Sketches can be moved around to exclude or include various features and to help decisions regarding the format, whether this should be vertical or horizontal. Enlarging your sketch can be difficult, although this does become easier with experience. I usually make a centre point, then start with the highest or tallest shape and work from there. Do make sure that your images are in proportion to each other.

All this could be a bit daunting for the absolute beginner, but the drawing process really starts with noth-

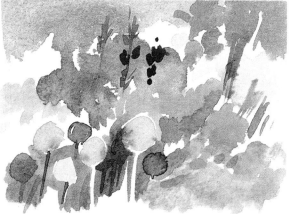

Ideas

These three small sketches are preliminary jottings, first ideas which may eventually be a larger painting – sometimes they are impressions remembered, and sometimes an attempt to get my thoughts organized in a pictorial way.

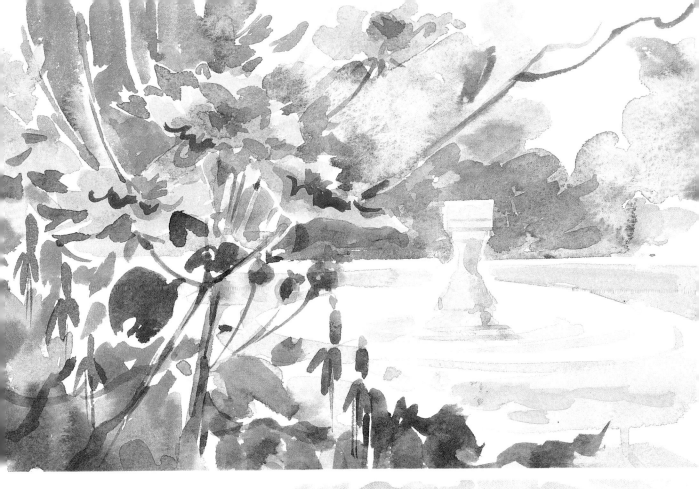

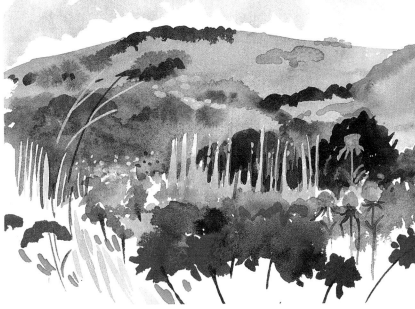

△ *Roses*
These roses in a formal garden were an attempt to find a different composition; besides, the transfer of scale – large to small and small to large – is often most effective. Although in no way a finished painting, the basic idea and a feeling of recession were both achieved. Rather than attempt too much, small sketches such as these will help you gain both confidence and expertise in the use of colour and with your brush.

▷ *The South Downs*
This sketch was jotted down whilst painting something else. I liked the tall, spiky flowers against the dark background of the hills, and the complementary colours of red and green were also nicely juxtaposed.

ing more complicated than a shape or shapes, proportion and scale. Think of the different shapes of leaves: are they wider than they are long, or triangular or oval? Do they overlap each other, point up or down? Start in small ways and enlarge upon those. Some artists begin with a motif which interests them, and will then enlarge upon that. There are many ways of starting and few of finishing.

To work on a small scale is somewhat comforting; it is important to convey the main idea, to make a statement and to make it clearly. These preparatory sketches were drawn not only to put down on paper the idea of summer flowers, but to establish the most important elements, whether shape, colour or composition. Being small avoids the problem of a great deal of drawing, or covering large spaces, and if your idea doesn't work you haven't wasted too much time or paper. Besides, the very concept of speed, large brushes and single-mindedness is exciting, whatever the scale!

Sunflowers

To be able to record anything pictorially needs a certain amount of skill, and to my mind, drawing underpins the majority of the subjects that you will tackle. To draw well requires regular and constant practice over the years – one artist I know remarked that every student should be compelled to spend the first five years drawing, and only drawing, before starting to paint! As regards learning to draw, it would be helpful to have a basic knowledge of structure and proportion, as well as experience in handling whichever tool it is you have chosen, be it pencil, conté or charcoal; and of course a certain measure of confidence which comes from practice. However, drawing can take many forms – it is even quite possible to draw with a brush, and in doing this you are halfway to painting. To be able to put down ideas successfully also takes some practice,

An Idea

Pencil sketch ideas for a painting, recollections of a holiday in France quickly noted for future use: these constitute the germ of a project! A further colour sketch was made developing the theme – in this instance, incorporating a cottage seen against dark hills.

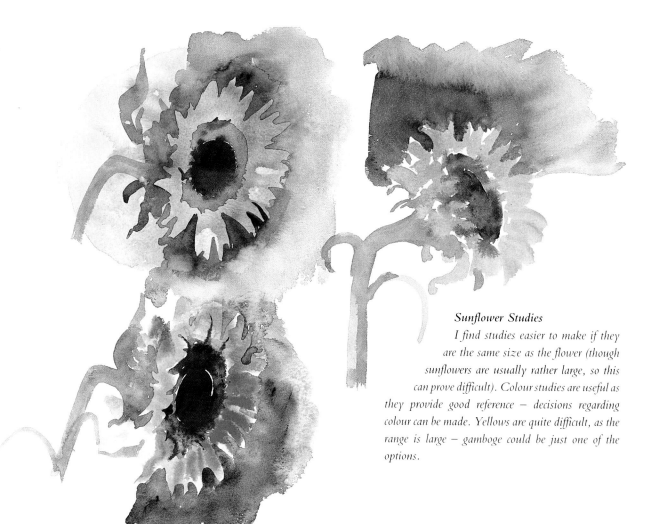

Sunflower Studies

I find studies easier to make if they are the same size as the flower (though sunflowers are usually rather large, so this can prove difficult). Colour studies are useful as they provide good reference – decisions regarding colour can be made. Yellows are quite difficult, as the range is large – gamboge could be just one of the options.

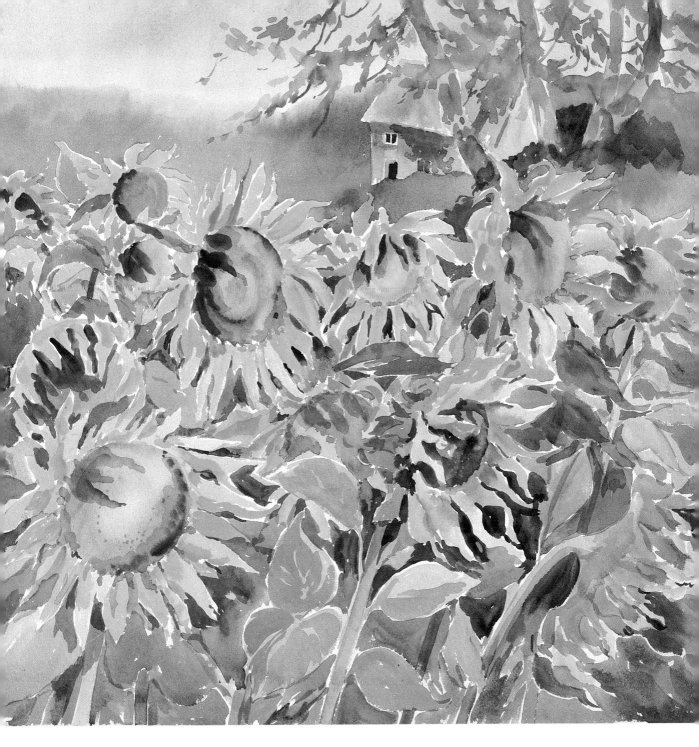

besides which the result often depends on who you are drawing for, whether it is for yourself or for someone else. The idea has to be 'read' successfully, and it is important that it can be transferred or interpreted from line into tone and colour.

The drawings here represent some thoughts on painting sunflowers – pencil sketches, a colour sketch and two study sketches. These are all starting points for a painting and ideally should take place before you begin, particularly if you will be working in the winter and removed from your subject. Sunflowers are always enjoyable to paint; I try to grow some most years as they are exciting and vital plants.

Sunflowers

Sunflowers are much larger than most flowers. The colour is often brilliant, and seems to require special study to achieve the exact hue. I found that cadmium yellow had the right intensity and brightness, but there are various cadmium yellows – pale, deep and orange. In this painting I used cadmium yellow deep to paint the flowers. There was no preliminary drawing apart from the rough design and colour sketches, as I particularly wanted to achieve a freshness of approach that only a direct painting can give. Drawing the subject too carefully can result in a restrictive style. However, each artist must find his or her own methods of working, so it is a good idea to try many ways.

Sketching

All the sketches on the following pages were made on the spot in sketch-books, mostly on cartridge paper, and show variations in approach and media. The gouache sketch of a buttercup field was painted on sand Ingres board – I keep a ready supply of these boards, 10 × 8in (25.4 × 20.3cm) in size, and find the neutral base colour helpful. The pen sketches are drawn with a steel nib and Indian ink (as opposed to fibre-tip pens); although rather inconvenient, I prefer the line, and put up with the odd blot. Most of these were made either as ideas or just for pleasure, but occasionally such sketches are useful in helping to work out certain problems; often one is confronted with difficulties regarding drawing, perspective or eye levels, and these can only be resolved by working out solutions on paper.

Personally, I find standing at an easel works out best; you are free to move around and stand back. On the other hand, painting like this can be very demanding, so *sitting* at an easel can be the next best thing; but hunched up over your work on an uncomfortable stool is not recommended, particularly for long periods of time!

These two pen sketches illustrate different eye levels. It is quite possible to come across a situation which appeals to you while you are standing, but as soon as you get your painting stool out and sit down, you find you can't see anything much, but can only peer through the vegetation. Either way you will have to decide in this situation how to render the light colour of the grasses and suchlike against the darker background, and so there are many questions: stand or sit, masking fluid or scratching out?

Buttercups
Suddenly the field opposite my house was lit by the sun, and colour seemed to be the only way to capture the intense brightness. This gouache sketch took approximately half an hour, and was primarily an exercise in light.

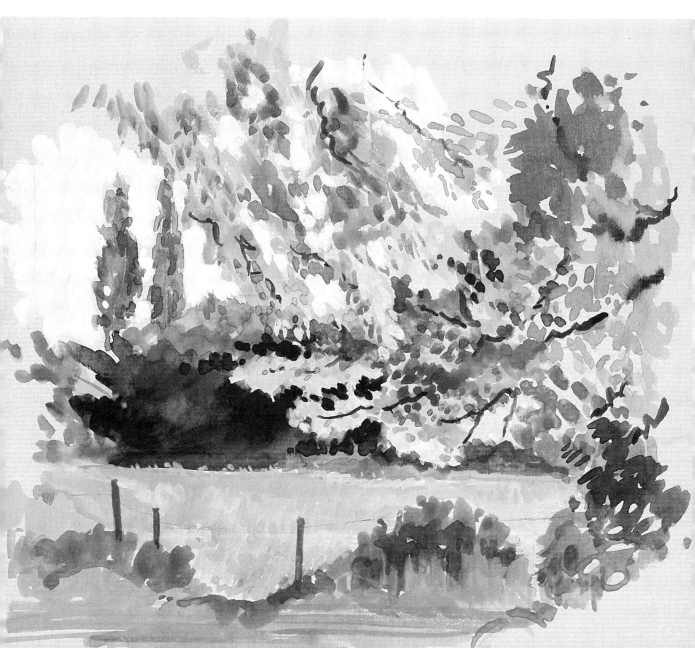

Sketches from the Sketch-book
These two pen and ink sketches were drawn without any previous pencil work. The washes were put on afterwards. Both could have been developed further, but were drawn in spare moments, really to keep my hand in practice.

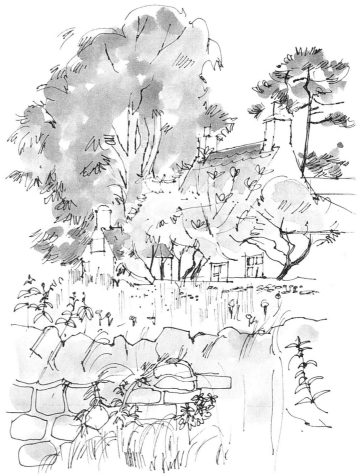

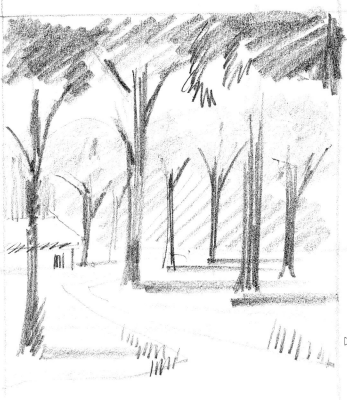

The pencil sketches are no more than jottings down at an odd moment, although you should always carry sketch-book and pencil. Visiting the R.H.S. Gardens at Wisley doesn't leave much time to sketch, but the couple standing in the herb garden against the sun provoked the germ of an idea, so down it went in a few minutes as an aide memoire.

▷ Two sketch book studies painted from the same spot (one with a higher eye level), in an attempt to work out how to treat the grasses and cow parsley. When painting delicate and light plants, you sometimes need to use a masking fluid to enable you to paint broad areas easily. Occasionally, a pen line can help to provide the detail you need.

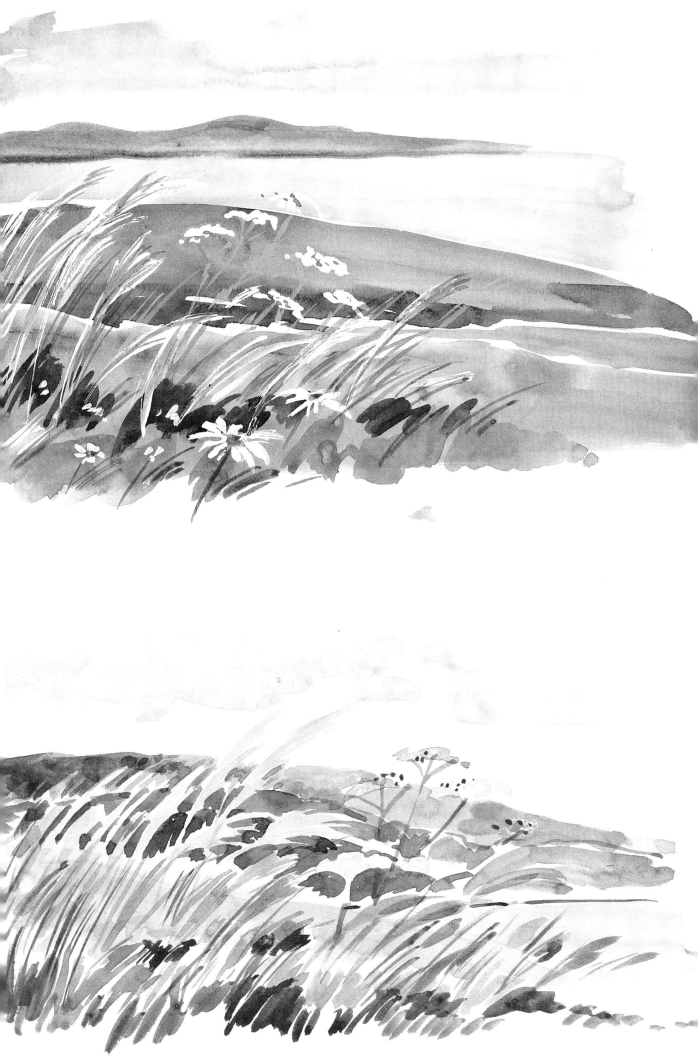

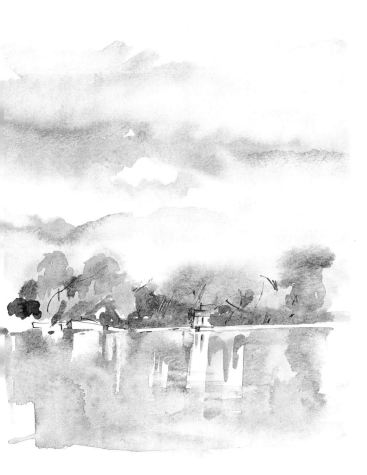

Motivation

Finding the motivation to start is due in part to confidence and knowledge, and partly the result of some inexplicable desire to capture a particular moment. Sometimes it just occurs arbitrarily: it could be a shaft of sunlight at the right moment, or a chance happening which inspires you. At other times you work hard to achieve it: you prepare yourself, stretch your paper, have your subject worked out in your mind, put pencil to paper, set up your references and leave nothing to chance. There are other sorts of motivation, of course – money, commissions and so on – but it is self-motivation that we all need.

Learning to be an artist requires many things, but to my mind amongst the most important is the ability to be observant, to appreciate various effects seen on walks and excursions, and to become more perceptive in every way; and also to have your materials to hand so you can record your experiences. A notebook and pencil could be enough. One day in the autumn near my home, a sudden storm and low sunlight provided a glow on the trees which was unforgettable.

Getting started is really up to you, and a time when you must be decisive; for example, ask yourself why you liked

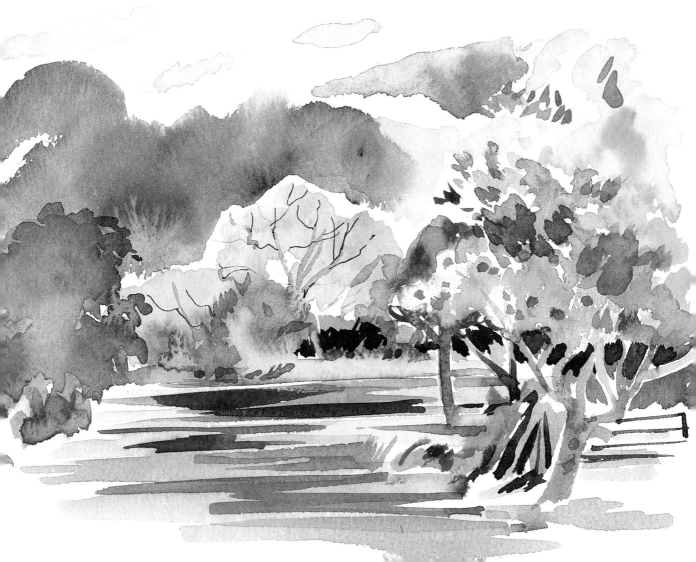

a particular scene, and isolate its qualities: this could include many things – a bit of romanticism, memories, light, an intriguing view, colour, perhaps just something indefinable. And some things such as flowers are just lovely, and invite the artist to represent them! They can be an inspiration at any time of the year; in mid-winter cyclamen, hibiscus, hyacinths and pansies are all available, and in early January you can sometimes even find daffodils. Consider also that landscape does not necessarily mean tracts of countryside, but can include views through windows, interiors and suggestions of space. So no excuses – autumn and winter can be very busy for artists! A time maybe to finish the summer painting, to set in order photographic references, and to use some of the ideas started in the summer.

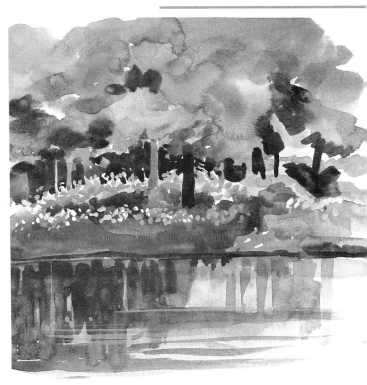

The four studies on these pages are examples of certain aspects which could provide the motivation for a larger painting. You have to work very fast to capture that elusive sunshine, so small paintings are often easier and quicker to finish. Below left is a sketch in autumn of an indigo sky, and sunshine which lit up the willow tree in the distance. You must always be prepared to note the colour first and paint afterwards, as that sort of sunlight disappears really quickly.

The sketch above left is a colour note of winter trees and reflections in February, which is the opposite of the study of yellow flowers in midsummer (above right). The last idea (below) is a Devon scene showing English countryside, but with foreground grasses and cow parsley indicated.

While these sketches may or may not be used in any way, they serve not only to keep me in constant practice, but to alert my senses to changing weather conditions, and to provide landscape reference for future use.

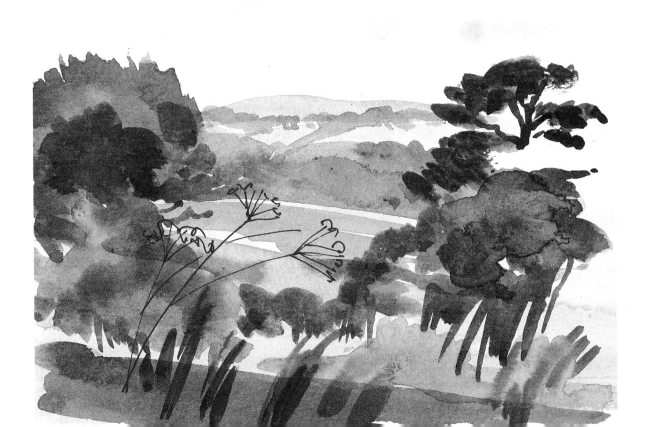

Wisteria

The previous sketches deal mainly with the landscape, but often it is the flowers themselves which provide the stimulation. If you are inexperienced it is useful to make studies first as these will serve to give you the background needed in, perhaps, a finished painting. Your studies will provide colour information, besides showing you the sort of approach needed: for instance, should the background be painted first or last?

Wisteria is not the easiest flower to paint, particularly in situ as it mostly hangs above your head! However, the flowers are a delicate mauve and hang in racemes, and certainly give inspiration to artists. Some wisteria grow to amazing heights; the tallest I have seen was in the Savill Gardens, supported by a tree. The flowers are produced almost before the foliage, and just to see these lovely blooms is motivation enough for me. I have made various studies, but felt that this was one (below) that could be used as the starting point for a larger painting. The window is intriguing, and the yellow-ochre bricks make

a good contrast for the mauve wisteria. With flowers there is always the danger of them disappearing before you make other visits, and indeed, this wisteria was quite severely cut back, so the situation was never the same again.

Enchanting though wisteria is, it is quite difficult to draw as the petals are small and intricate, so a certain amount of preparation is needed. Large-petalled flowers are nearly always easier to paint as you can use a large brush and fluid watercolour.

With flowers such as wisteria, it is often necessary to go back to drawing and decide on the basic shape, and how the flowers hang and fall from the stem. The character of the flower should be portrayed, and the artist should know how the flowers are formed – with wisteria the individual flowers have stalks and are in a spiral formation. Many wisterias are mauve and lilac (although some are white), and it is interesting to find the right colour as there are many variations – ultramarine and alizarin crimson is just one. With colour in mind, the combination of the complementing purple and yellow could help an overall scheme.

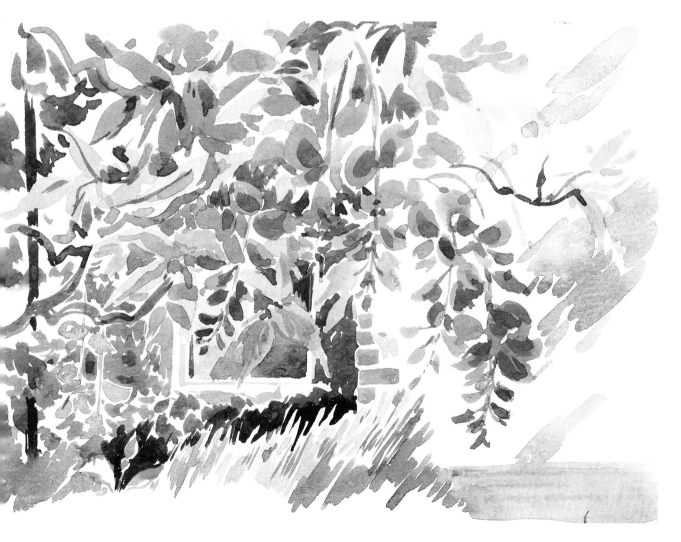

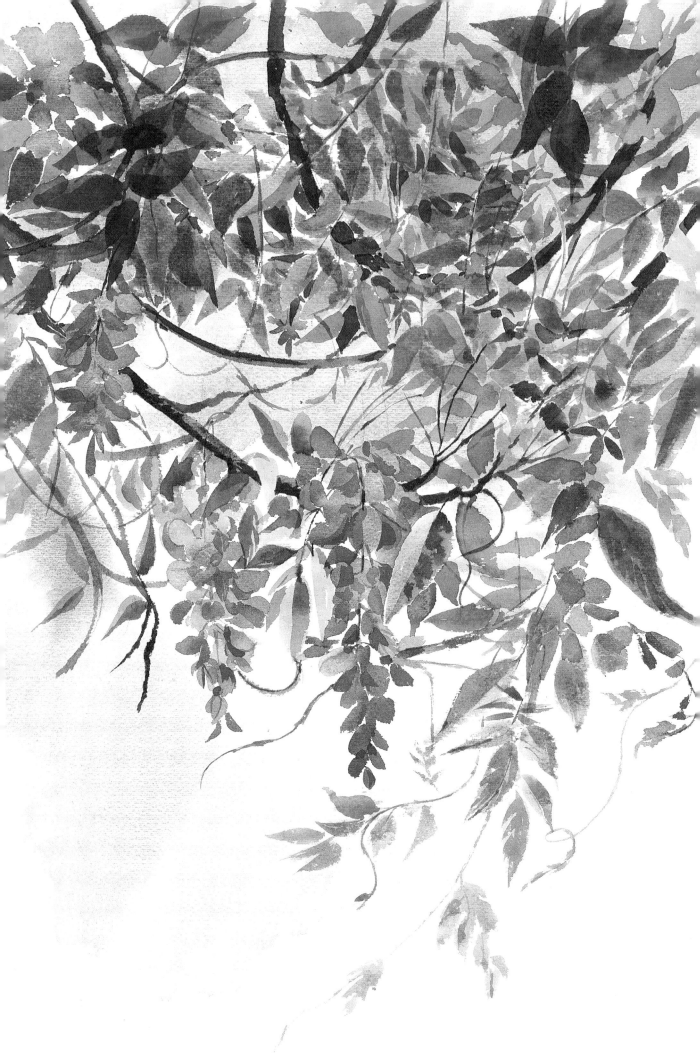

Creating a Further Dimension

Backgrounds

One aspect of watercolour painting that many find diffi-cult is knowing how to fit the chosen subject into a situation. Painting a group of flowers can be reasonably within one's scope, but knowing how to fill the rest of the paper can often pose a problem. Occasionally the subject and its setting can be seen simultaneously, but frequently the main subject is painted in isolation. In this case imaginative perception is very important; also try only simple ideas first of all.

You can think ahead and paint your background first before the subject, remembering of course to leave whites for white areas either by masking out, painting round or blotting off. One way that I have found helpful is to paint a very soft sky area and then to paint the foreground. The middle distance often falls into place, but the soft cobalt sky, white clouds and perhaps darker areas can be very sympathetic. This is most easily done on stretched paper, but do study skies first!

There aren't any rules for painting as such, but some-times tried and tested methods can help. For landscapes, try working from light to dark, where a *one, two, three* approach can be useful – that is, sky (1), foreground (3), middle ground (2), with the foreground being the darkest and most prominent part. This can work in reverse, and

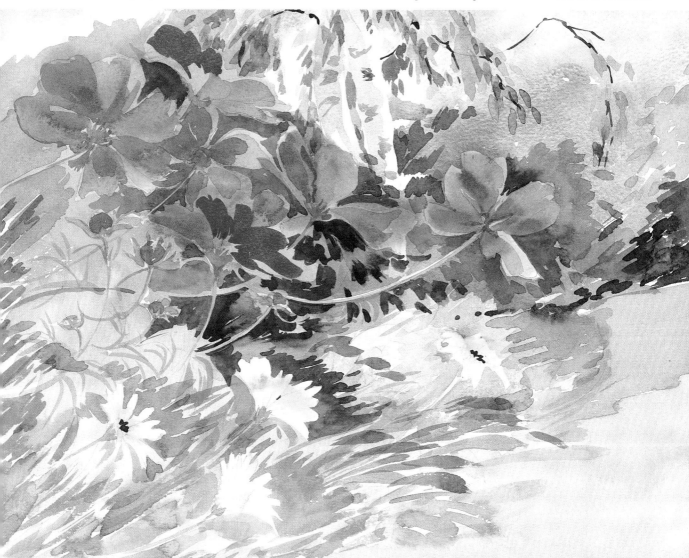

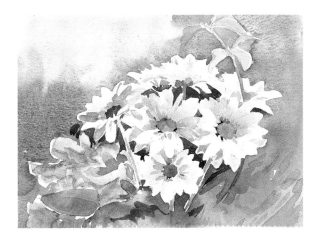

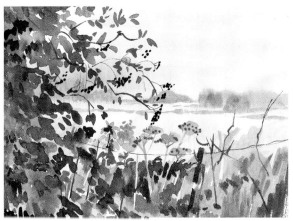

White Flowers

To paint round small white shapes is very difficult. The easy way to overcome this is to use masking fluid and then to paint right over that section; alternatively you can damp your paper but leave the flower area – the paint will spread on the wet parts, but not on the dry. A third way is to blot out the flower shapes once the background is painted.

Summer Landscape

The background illustrated here is of the simple landscape approach. A graduated wash is used for the sky, the middle ground is yellow ochre, and the dense foreground of darker foliage shows some detail. A horizon line was dropped in while the sky was still wet.

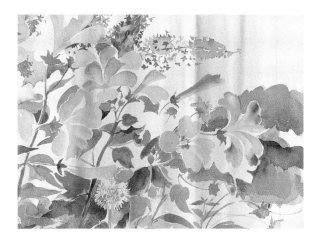

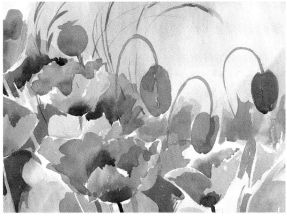

Pink Flowers

In this example, the background was painted first in a soft blue-pink which echoed the colour of the flowers; while the paint was wet, further colour was dropped in to resemble flowers. The greenery was used to hold the edges and make the shapes, which were created with both hard and soft edges.

Poppies

Here I painted a soft sky area first, then the lighter green which formed the foliage area. Painting the darker flowers and leaves came next; and you must allow for any white flowers either by masking or by using gouache.

◁ *Cosmos*
This painting of cosmos is seen against the background of the garden; in this case the flowers were painted first, and the background was used to hold and define the flower shapes and stems.

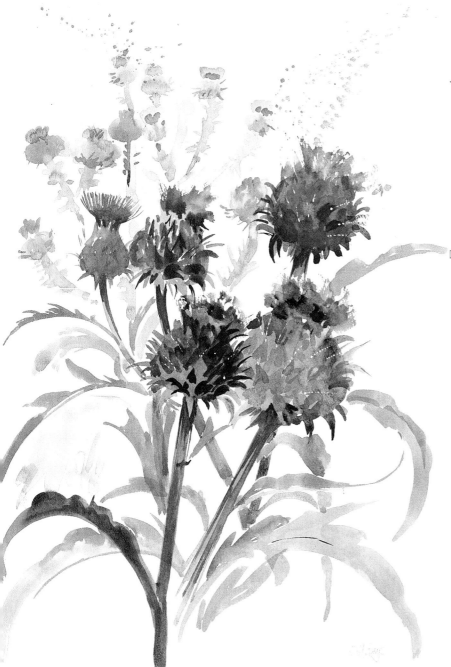

◁ **Using White Paper**
If you want to create a simple illusion of
space, try using a grey shadow behind
your painting. These shadows could be of
the subject itself or of other plants. This
sketch painting of globe artichokes is
quite a good example: although painted
on white paper, the light thistles behind
create a feeling of space.

▷ **Using Tinted Paper**
In this gouache painting of a flower shop
in Petworth, the background more or less
takes care of itself, and because the paper
is dark the colour shows through and
creates a feeling of unity. Painting on
tinted paper can overcome background
problems, but you will need to use some
body colour for the highlights. This is
particularly useful for painting spring
blossom which often has small petals and
is very light in colour.

it is an interesting exercise to try different ways of creating
a feeling of depth.

Paint around your subject: this sounds easy, but in fact
it is fraught with difficulties, the main ones being (a) that
you don't mix enough paint; (b) that you are too slow,
involving drying problems; (c) that it is impossible to paint
around small areas. One way to overcome some of these
awkward problems is to compartmentalize your work so
that the areas you are painting are smaller and uncon-
nected. Nearly all the problems associated with painting
backgrounds can be resolved with constant practice and
determination; a great many students simply do not carry
the painting through to the end. Painting is a lengthy
business, but with experience you do speed up – just be
prepared to throw away a large number of practice pieces!

While painting landscape, the 'problem' of a back-
ground is non-existent since the landscape often provides
both the background and the setting in which the flowers
grow. In the painting of a garden in high summer (see p.
20), the background consists of the flowers and foliage
itself, and you paint both simultaneously.

The majority of those students who like to paint
flowers, literally paint flowers and nothing else, or do so
with no thought at all as to the overall composition, as a
result getting bogged down with the actual technique of
painting around small shapes. It is essential to think
beyond just flowers, and to have some thought as to their
situation or the way they are arranged. To paint flowers
in their natural state does overcome this problem, and to
be able to combine them with landscape is a goal worth
attaining. Still-life painting is also excellent practice, and
helps you to paint in the cold winter months when it is
impossible to get out.

To be able to paint reasonably successfully it is essential

to be organized, not only with respect to your materials (see p. 124) but also to the order in which you go about things; that is to say, you should keep one or two options open when confronted with a subject. When painting outside in front of the subject, it is all too easy to get led astray – there are so many exciting aspects to making a start that some people actually panic – besides which there is the very important time factor to bear in mind. The painting day could be interrupted by meals, but mainly it is the quality of the light which can change everything; with watercolour you must be direct because it is well-

nigh impossible to return to a subject and find it exactly as you left it. In England the weather invariably changes, and certain things are never quite the same, which can make the artist's task harder. So it is advisable to have some method in procedure.

The two examples here help to overcome certain problems; one of these is to decide what sort of background to have – in the first, a grey is used to suggest another dimension, in the other I deliberately start with a base colour and then decide to use either gouache or watercolour.

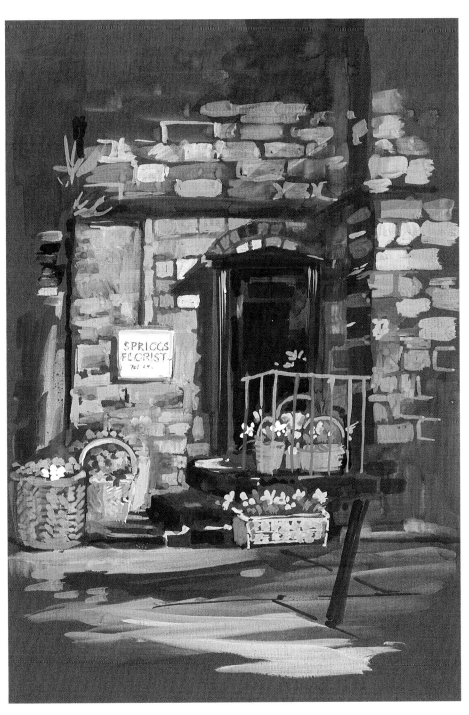

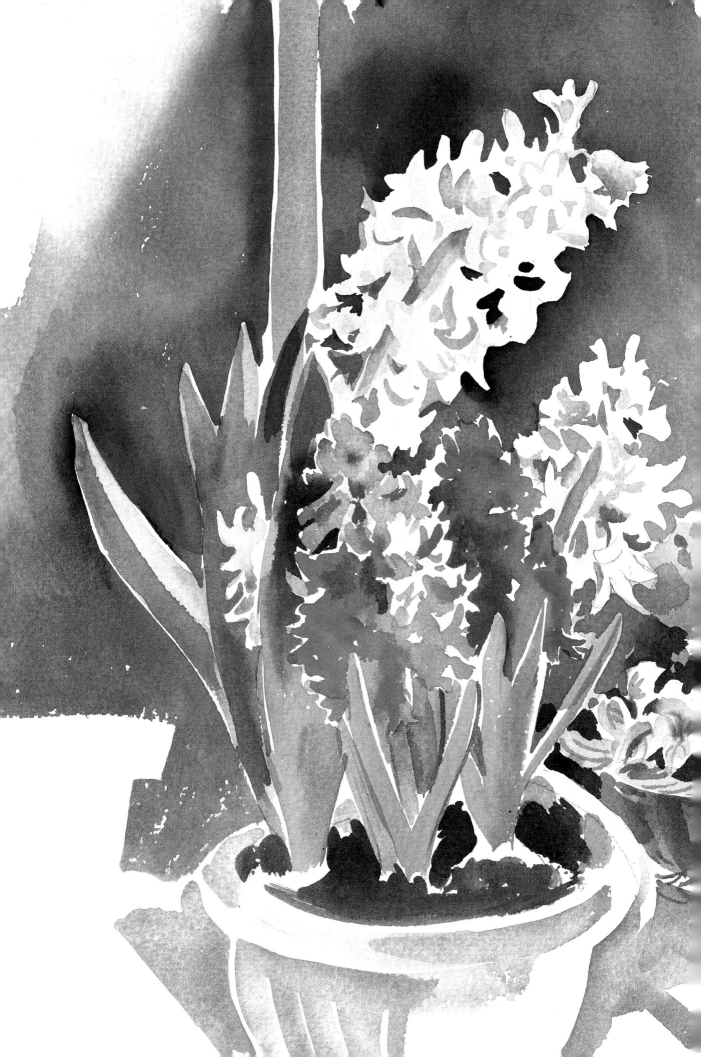

Compartments

These two paintings of potted plants exemplify painting backgrounds in parts or sections. The subject is painted in a straightforward way and the background painted last, and in these examples it holds the lighter shapes of the flowers. As with all washes, try to mix enough (too much, in fact), so that you don't run out of colour at a crucial point, and paint quickly and fluidly in the isolated sections. As the background areas are separate, any small deviation in paint colour won't be noticed. These paintings of flowers show an approach which could be carried further; for example, subjects like these can be placed in other settings and thus create another dimension.

Painting plants against windows is an interesting idea as you usually get interesting back lighting, or rim lighting. The light factor is most important, with windows you can arrange the direction of light to suit you.

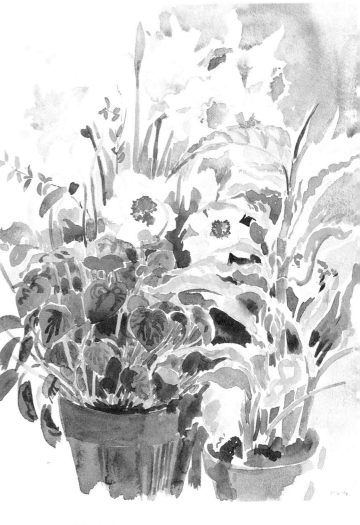

△ *Narcissi*

◁ *A Simple Background*
A bowl of red and white hyacinths and a basket of plants against the window are the subject in this painting. The simple indigo background holds the shape of the white hyacinth, and yet conveys another dimension. The background was painted quickly around the flowers, and the compartmentalized shapes helped the wash. It was a pleasant exercise, but reminded me to try to get my hyacinths to grow at the same rate the following winter!

25

Relationships between Flowers, Foliage and Distance

Sometimes simple formulae can help aspiring artists. For example, on a misty day trees and hills in the distance fade away and are hardly there; and then as your eye travels to objects immediately in front of you – say, plants and bushes – these become clearer and darker. In order to create this impression on a flat surface we can assume that we have a distance, a middle ground and a foreground, a concept that was used by Claude and by Turner to create the idea of distance in a landscape; in fact, such strata of the landscape often appeared like the wings of a stage. There are many variations, and no doubt when travelling around you might well see the opposite – dark background and light foreground.

I usually find that to think in terms of foreground, middle ground and distance is helpful. This is only a general idea, but it can help to paint the sky first, too, because not only does this give you time to think about the rest of the painting, it is also an effective way of covering perhaps the largest area of your painting surface. You can then wash in your foreground and nearer middle ground whilst your sky is drying. I realize that there are other considerations to decide upon, but to complete large areas of wash in the first instance is always a good plan. And although I am not happy about using the word *formula* (as there are always variations), this word works for me – it brings with it a working practice which is good to adopt.

▷ *Summer Garden*
This is a far more complicated painting, but still shows the elements of foreground, middle ground and distance; and if the painting were analysed you would see definite strata, or layers, of tone. Colour plays a part as well; usually reds come forwards and blues recede. There are always exceptions, however, and it is challenging to discover these and note them down.

▽ *A Cotswold Church*
This is a fairly clear example of foreground, middle ground and distance. Here the middle ground is light and the distant trees and church darker, but with the foreground grasses and bush the darkest element.

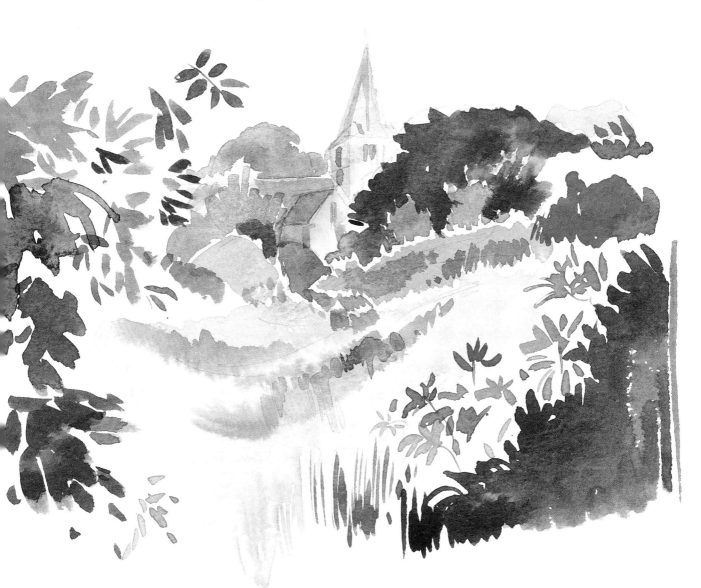

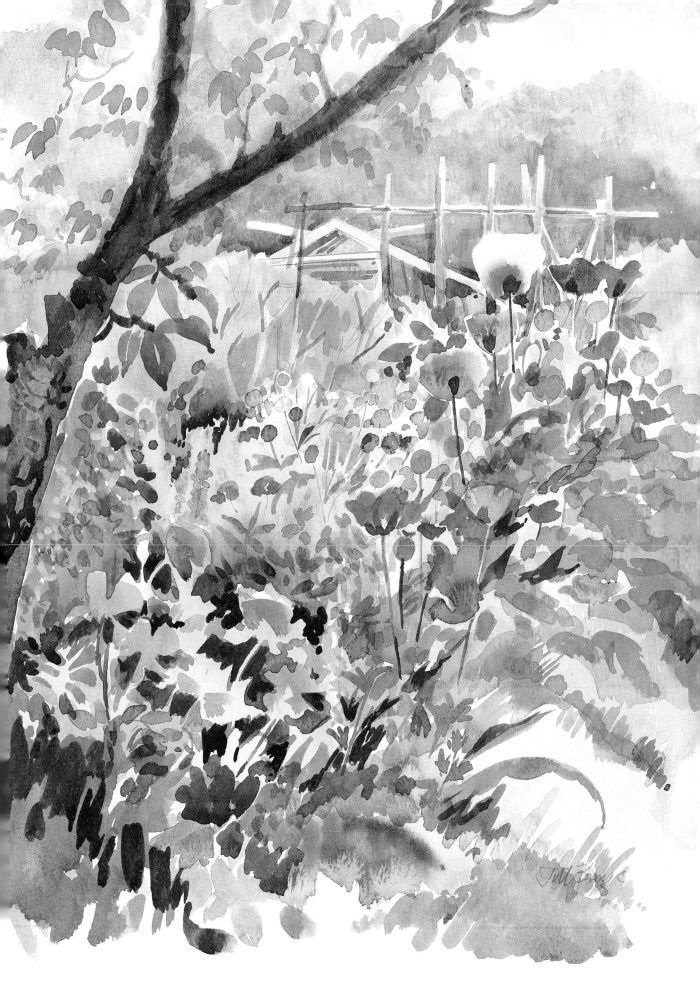

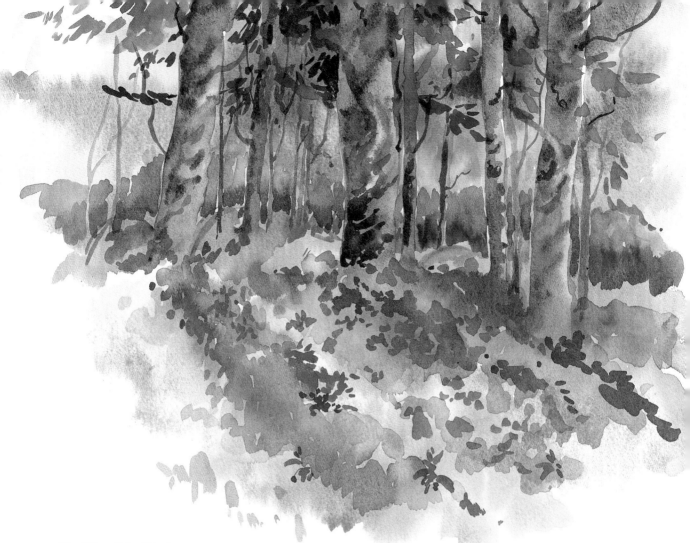

The Edge of the Wood

Painting as a Whole

Thinking of your painting as a complete 'whole' often means that the general design will take care of the background. However, this can involve a lot of preparation, far more than most artists are willing to give: it means rough designs, try-outs, and leaving nothing to chance. On the other hand, it also indicates a willingness to work all over the painting at the same time, rather than concentrating solely on any one part. This is something that most watercolourists have to do when working in the usual way of light to dark, and when working with large areas of wash, such as sky or foreground; they begin on the detail later.

Painting in gouache on coloured ground means that you don't have the problem of resolving a background, as your ground is already stated. In watercolour, the use of coloured or tinted paper has the same effect, and you can get your lights by using body colour. Tinted watercolour papers are available in sand, grey, cream and so on, and certainly create an all-over feeling to a painting. Of course, many watercolourists tint their own paper before

painting, but it is wise to wait until it is perfectly dry – overnight perhaps. This is a useful idea if painting architecture, when a warm effect is needed, or maybe just to give your painting a sort of mood. In any case, it should be subtle and not too strident.

Using tinted paper can overcome the background problem, in the following way: the paper itself is already creating a middle tone, so your darker tones are more easily achieved – although body colour has to be used for the very light areas. Many artists use this method successfully, and it does cut out the need to be constantly concerned with lights and highlights. In fact, tinted paper gives a painting the depth that in pure watercolour so often eludes us. The fact that you are using white paint (gouache) for your lights doesn't matter – the method is up to you.

Creating a painting as a whole is something that comes with confidence, and with having the courage to make mistakes. Painting for me is often a nail-biting time (that's if I have time to bite my nails!) but it is also exciting, and so often I find myself asking 'Has the wash dried?', or 'Dare I?'. Most would-be artists are too timid, and it is much better to have a go, and throw caution to the winds.

Foregrounds

As well as the technical aspect of painting backgrounds, the idea of foregrounds can upset some students; the composition *should* take care of what happens, yet sometimes one finds large and empty spaces which never seem to look right. If this is the case, there are certain solutions, depending on how the painting is composed. One is to increase the foreground interest by using more detail; this can involve the use of texture in earth, stones and suchlike. Another is to employ shadows which come from somewhere out of the picture area. These ideas are rather a 'last resort', but can get you out of trouble. A deliberate blurring of the foreground can help, rather like the idea of a vignette, although it can look forced unless great care is taken.

Lively brushwork and subtle changes of colour in the foreground can often be enough to create interest in flattish areas of colour. Many students worry unduly about this aspect of painting. Experience and a careful use of masking (laying a mount over your painting to determine your picture area) can also help.

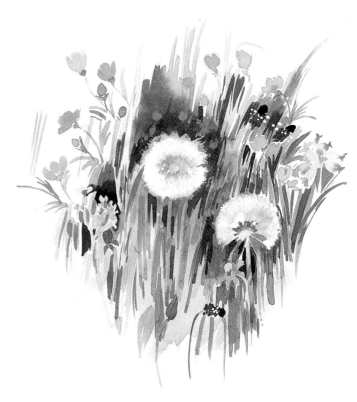

▽ *Surrey Woods, Early Spring*
This painting illustrates the use of brush strokes and shadows in the foreground. It was actually a rather muddy path with odd bits of grass, so the various browns and greens were a device to lead the eye into the very bright green in the centre of the painting.

△ *Dandelion 'Clocks'*
Although not quite a vignette with faded-off edges, this small painting, 8 × 8in (20 × 20cm) was deliberately left to fade away (you have to stop somewhere!). The pale ochre background was painted first, and some white gouache was used on the dandelions.

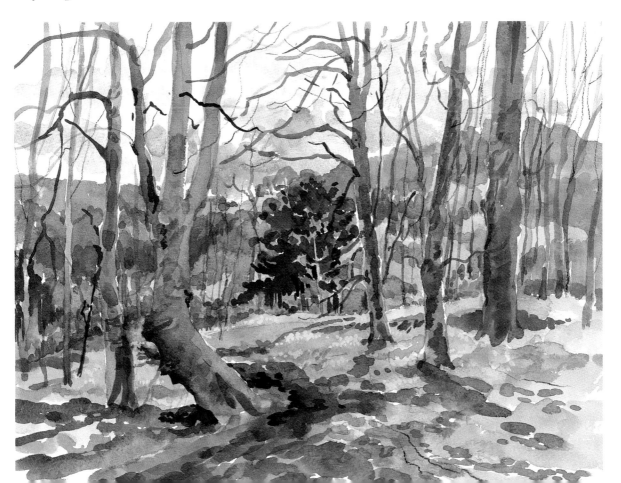

Recession

The idea of recession (the illusion of distance) in a painting is intriguing, and can be achieved in various ways. You can use tone, with things further away being lighter and those in the foreground being darker; allied to this is colour, and realizing that blues recede and reds come forwards. Size and scale can also give the idea of distance, as can sharpness of detail in the foreground. Deliberately contrasting the size of, for instance, a plant with a large object in the distance can be effective, a technique that will be discussed in a later chapter (see p. 48), along with the use of contrasting shapes and colours. Some artists deliberately forego recession by flattening the picture plane, as if viewing from above; this can involve pattern-making, which is another interesting concept. The plane of the painting is tipped up, and this creates diverse shapes and patterns on the flat surface of the paper, leaving the onlooker to work it out. *Trompe l'œil* (meaning 'deceiving the eye') is the ultimate in illusion and was used to great effect by Renaissance artists, either to create the impression of distance, such as distant views, or to imitate certain effects: painted marble colours, false doors, and so on.

A knowledge of perspective is very important and certain basic principles should be mastered: if we are creating an illusion we should get it right. Even the smallest error can provoke a niggling doubt in the eyes of an onlooker. Although we know that objects in the distance appear smaller, it is amazing how many students ignore certain simple rules. However, if when drawing you *can* trust your eye to guide your hand, do so, and only if your drawing looks wrong check your use of perspective. Eye levels and angles are important in basic drawing – look at your drawing in a mirror to check discrepancies.

Simple illusions, not too complicated, can appeal to someone whose primary interest is flower painting rather than landscape. Alternatively, the idea of enriching your landscape with believable foreground interest is appealing.

▷ *A Griffin at Polesden Lacey*
I spotted this guardian of the garden whilst visiting the lovely National Trust property of Polesden Lacey. The beautiful gardens and walks look out over a deep valley to hills, fields and trees. In the distance, the grass seemed almost as green as the grass in the foreground, and yet it was a long way away; a conscious effort had to be made to lighten the distance and therefore create recession. Painting in spring is a delightful if a rather chilly operation; drifting forget-me-nots or a haze of bluebells can look beautiful, but a sniping north-east wind is not kind to outdoor painters. Trees in spring are somewhat easier to paint than when in full leaf, as the bare branches are not obscured by heavy foliage.

▽ *Chertsey Meads*
This rapid sketch of flat meadow-land shows how trees in the distance appear more blue than the foliage in the foreground.

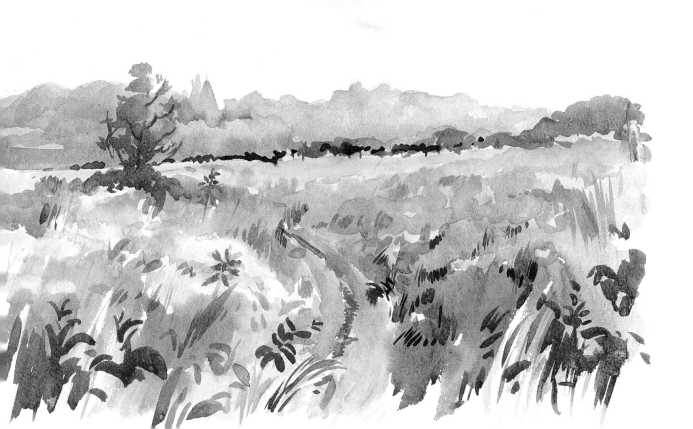

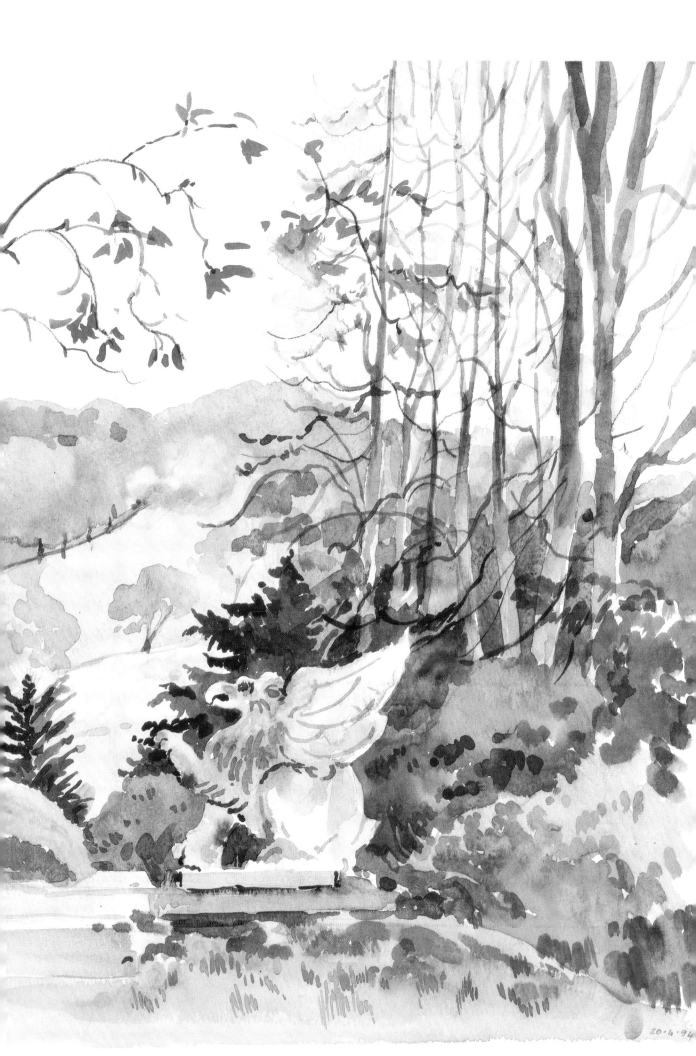

20·4·94

Technique Explained

Painting well does not depend on whether you have certain colours in your palette, or paint with a certain sort of brush. In the early days of painting, artists made their own brushes and ground their own paint. While, fortunately, we don't have to do this today, we have to find the same kinds of motivation and make preparations just as they did. Technique, of course, does play a major part, but a knowledge of drawing, tone and colour, allied to enthusiasm and creativity, is, I think, more important.

Watercolour

Watercolour can be used in various ways. It is essentially a transparent stain on white paper, and one in which 'white' is actually the white paper itself. Generally speaking the method is to work from light to dark. In order to achieve brilliance, colour should be as pure as possible; the technique is either to mix on the paper, or to overlay pure colour. Colour can also be mixed on the palette, which can be a large plate or even saucers if you need a large wash.

It is always a good idea to get the best materials possible; if you can't get the best paints, do at least choose decent watercolour paper; and if you have to use cartridge or a lightweight paper, go to the trouble of stretching it first – as a student I never used the kind of paper I use now, but always stretched cartridge. Otherwise you may find your paper buckling and cockling, which is so frustrating. In any case, your surface should be firmly attached to a drawing board, at least to avoid working at an angle which can lead to all sorts of trouble. When painting in oils you *have* to put your work on an easel, but watercolourists often work in a sloppy way. Also, try to make your vertical edge truly vertical, if you can.

Generally speaking, your watercolour materials can be minimal and should go into a large satchel; nowadays they are readily available and easy to use, and include sketch-books, watercolour sketch-books, blocks and many other such items, all making the artist's life much less complicated.

With regard to technique, there are no hard-and-fast rules today; technique gets mixed with style, and your own individual style will come with practice. There are certain techniques which can help you in various superficial ways, but with keen observation and study you will quickly pick these up. To be able to use a brush with confidence is your main objective. However, you should be able to handle wet-into-wet painting, and to use a dry brush technique, and you should also know how to leave white shapes and portray different textures.

White or light colours in watercolour have to be considered when starting. You can leave the white paper,

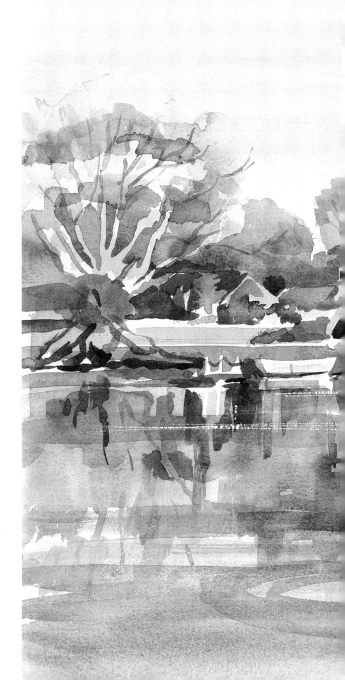

or mask out your shape by using masking fluid or some kind of paper mask, or use a wax crayon. Small spiky lines can be scratched out or lifted out when dry with a damp brush and blotted. I find blotting paper invaluable.

Quite often the most interesting landscape ideas occur at inappropriate times. Unusual colour tends to happen very early in the morning, when it is too early and often much too cold for painting. However, living by a river as I do is enjoyable whatever the time of day – there is always a wealth of bird life to see, and moving water gives a variety of changing images. And painting in winter is an experience, too: many artists get some of their best ideas from winter scenes, and certainly trees are easier to paint without leaves and all those different greens! But there are other hazards, cold feet being one, and paint which refuses

to dry. One way of overcoming the latter is to paint the sky at home first, or to paint it last, again possibly at home; you could also try using a brush directly, and cutting down on actual working time. This means honing down your drawing to the essentials, and being prepared for wet areas which never seem to dry. The river scene pictured below was painted on a very cold February morning, but the sun shone and everything was glowing in its light, ochres, siennas and umbers. I painted the sky at home first, and set out when it was dry; then approximately 1½ hours' work was done on site, and finally more time was put in at home.

This watercolour shows many of the techniques discussed. It was fortunate that the white dinghy was there when I first started, as it wasn't long before it was used to ferry someone to the island, and disappeared for ever!

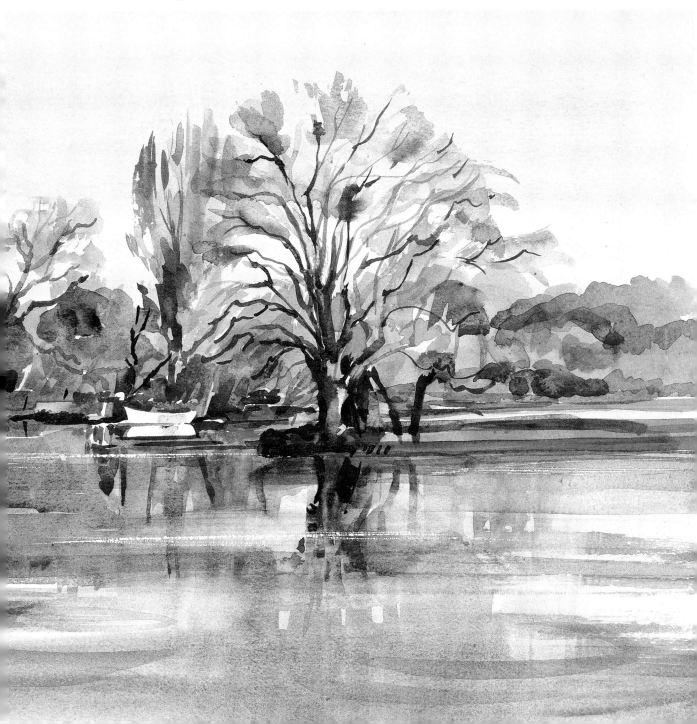

Gouache

Gouache is an opaque paint consisting of pigment and a vehicle such as gum plus chalk; it is diluted with water. It has a certain thickness and creates an actual paint layer, whilst watercolour is a stain. Gouache paint can be used in a deliberately smooth and flat way, but the kind of painting for which it is mostly used is of a more free kind, rather similar to *alla prima* oil painting. However, as with all mediums, its use is individual: thus it can also be combined with watercolour, pastel and ink for various effects; and one of its advantages is that it has great covering power, although practice is important (again) as with any medium. It can be used on white or tinted papers and boards – this colour base can be used to advantage.

I find that starting with thin washes and increasing the density as I go along suits me. It is not a precise way of working, but is one that can be adjusted as the painting progresses. You are not so much bound by rules such as 'light to dark' but, as in oil painting, can put in your darks first and finish with the lighter colours. It is often an advantage to work on a dark ground so that your medium and light tones are easier to find. Thus medium-toned ground such as sand or grey means that you can do without mid-tones, in fact making your task easier.

▷ *Bergenia*

Gouache on sand Ingres board. This lovely spring flower appears every year with its strong stems and pretty bell flowers. It was painted where it grew, so I used the fence as a background, trying to make use of the shadows of the tree above. I started with the flowers which I drew in with a brush, the background being painted last with fairly thin washes. The sand-coloured ground showed through to give an overall unity. I used Designers' gouache in white, crimson, yellow, ultramarine and chrome green plus burnt sienna. The brushes were a soft sable and a square-ended ½in synthetic.

▽ *St Ann's Hill*

Gouache on sand Ingres board. The bright yellow of the buttercups and the dark hill intrigued me. The painting was built up from slight washes, and some of the ground colour was left to show through. After an initial faint pencil drawing, I started with the sky, trying to remember that gouache dries lighter. I then established the dark hill which gave me my colour range (from lightest to darkest tone), and which meant that the colours in the foreground could be painted in. I used Designers' gouache – white, ultramarine, chrome green, burnt sienna, crimson, yellow ochre, spectrum yellow – and my normal watercolour brushes. I keep a separate palette for gouache paint as it doesn't mix well with watercolour.

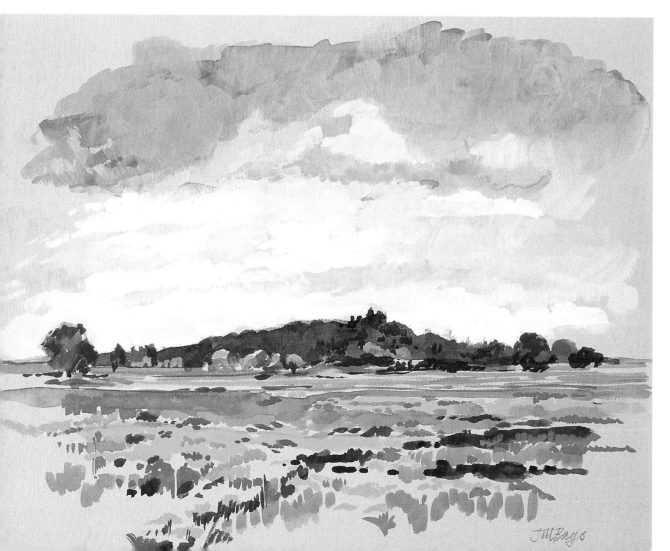

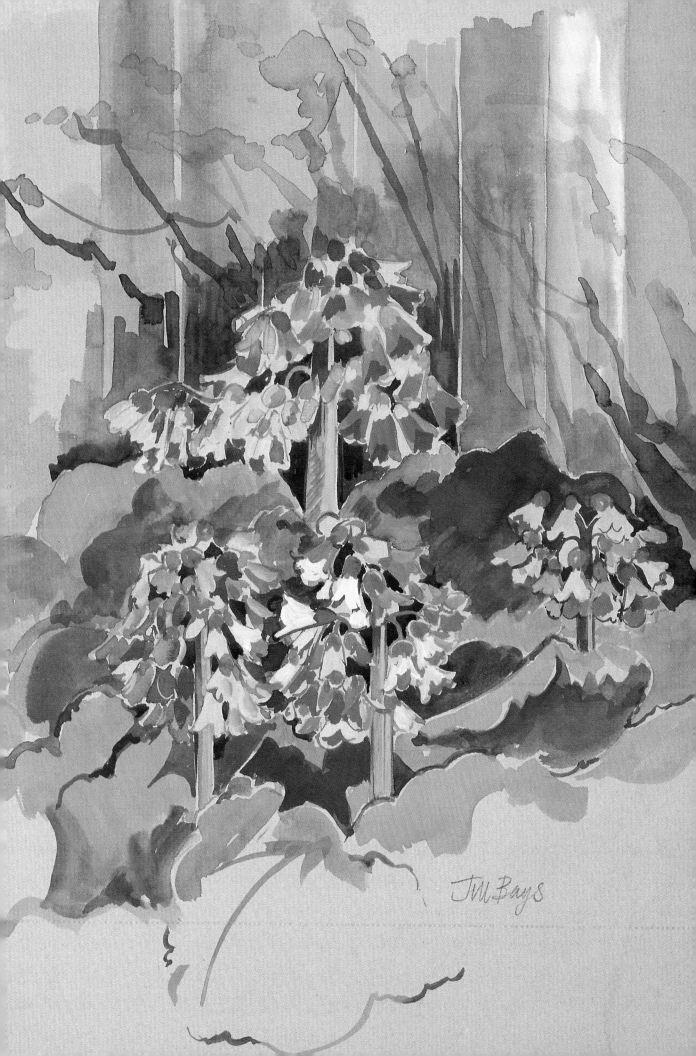

Line and wash

Drawing with a pen can be a fascinating pastime, and rather like writing, it is an opportunity to develop your own style. Washes may be applied as freely as you like, or they can be precise and detailed; colour can be washed in first before line drawing, or afterwards. Drawing is effective with ink or watercolour, pencils or crayons; and one of its great advantages is that the line holds the edges, so tone and colour are not quite so important.

There are no clear divisions between drawing with a brush, and painting. Using diluted ink can be a happy stepping stone to working with tone and colour, and details may be added with a pen. I am more than ever convinced that good drawing is the key to successful painting, and that the more you draw, in whatever medium, the more confidence you will gain. It is useful to have a sympathetic critic and teacher, as it is not always easy to see one's own mistakes. The ability to construct and draw in proportion is essential; if you take the trouble to master the elements of drawing and perspective, it will pay off handsomely and tackling tone and colour will then be easier.

An important point when attempting line drawing is to make sure that whatever pen you use flows freely. It is most frustrating to have a nib which spits, splutters and scratches, and is one reason why many people love using fibre- or felt-tipped pens; however, although these are fairly trouble free, the line they produce can be monotonous. A pen with a nib, on the other hand, provides a varied line, thin or thick and essentially expressive; various coloured inks can be used, or Indian ink which, being waterproof, means that you can draw first and place your washes afterwards.

Some fibre-tip pens are waterproof and others are not, and it is useful to find this out before you buy. Working in line and wash does not necessarily mean using a pen; you can try charcoal or conté pencil, or a water-soluble pencil, a medium which is useful for quick notes or when you want to cut down on your materials whilst travelling. You can in fact draw with more or less any kind of sharpened stick, from matchsticks to reeds or bamboo; it is great fun making and using your own pens.

Artists have used line in some way or another for centuries: Rembrandt used a reed pen for landscape, and would also work on tinted paper using line and wash, highlighting with white gouache; Turner, too, made a good number of sketches using pen and wash. Over the centuries many artists have used line to great advantage.

Nasturtiums
Drawn with Indian ink and a pen on a 'Not' or Cold Pressed surface watercolour paper. (Hot Pressed is a really smooth surface, ideal for detailed work.) The drawing came first and the colour washes later, with little or no attempt at tone.

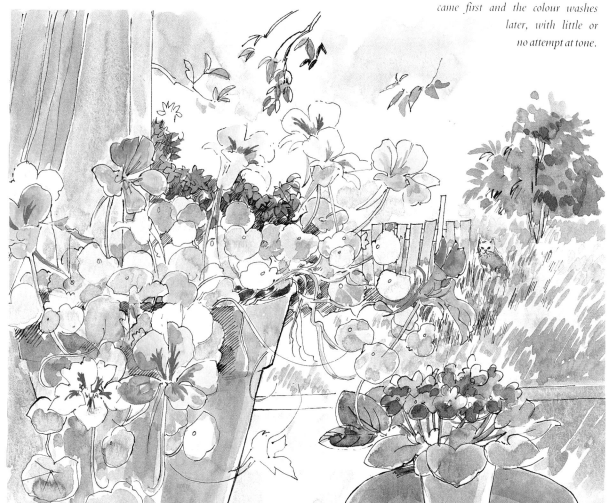

Catnip and Love-in-the-Mist
Drawing these delicate and small flowers almost needs a completely different technique. A fine brush or pen line could be incorporated into other compositions, to contrast with a broader approach.

Somerset Landscape
A pen was used to help foreground detail in this sketch. It is always useful to carry pen and ink whilst painting out of doors; these are certainly a permanent part of my equipment. A black conté pencil is also useful, as well as ordinary lead pencils of various grades.

Blackberries and Elderberries
Hedgerows are delightful, but a fair amount of patience is required to draw in the detail. Here, both a pen line and a brush were used to convey the idea of a field edge. The brush was useful as it gave some idea of tone, as well as line.

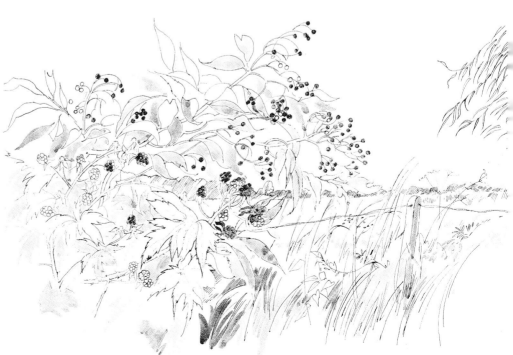

Watercolour pencils

Drawing and painting with water-soluble crayons is ideal for studies, because you can put in as much detail as you like and then spread the colour around with water. The colours are fairly delicate in the pure crayon stage, but more strident when dissolved with water. Certainly this is a 'drawing' medium, particularly effective for enhancing a watercolour and in picking out detail – for stamens and veins, for example, in flowers and leaves. The blending of colour is interesting, and one can learn a great deal about the interaction of colour. It is a sophisticated medium which, while appealing to amateurs, is in fact quite difficult to handle. The traditional belief that because crayons were used at school they are therefore fairly easy to manage, is a false one: good draughtsmanship is essential!

Drawing with these beautifully coloured pencils I personally find a pleasure, but there are several points to bear in mind. It is essentially a drawing medium, and to my mind is suited to smallish work as there is a great deal of hatching (shading) needed in order to achieve any depth of colour. You will also need a fairly extensive range of colours (I possess twenty), and must be prepared to mix and blend a considerable amount. Nevertheless, it is an ideal medium to carry when you need to be lightweight! All the principles which apply to other media certainly apply to the use of water-soluble pencils, by which I mean accuracy of drawing, knowledge of tonal value, good composition and use of colour. However, it is a medium in which mistakes can be corrected more easily than when working in pure watercolour.

In the two examples here, the pencils have been used in a similar way, with a great deal of diagonal hatching or shading. This is not particularly deliberate, but just the way my hand works! Left-handers will work differently, and I am sure that your filling-in and shading will be different to mine – for example, it could be more deliberate and follow the form more correctly; there are many ways, and you have to find your own.

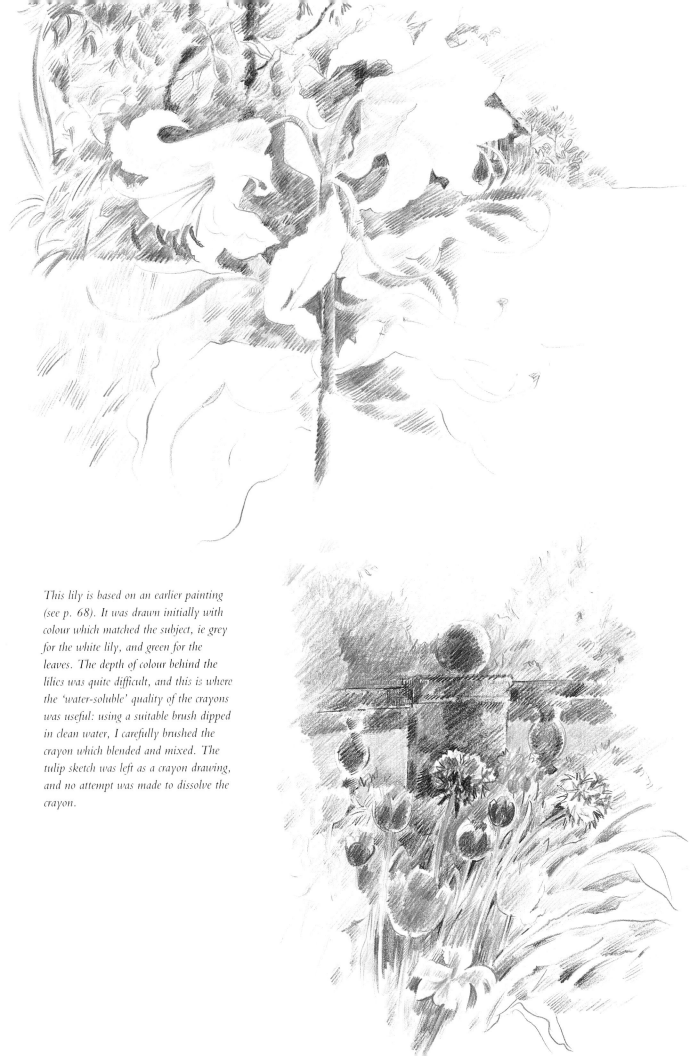

This lily is based on an earlier painting (see p. 68). It was drawn initially with colour which matched the subject, ie grey for the white lily, and green for the leaves. The depth of colour behind the lilies was quite difficult, and this is where the 'water-soluble' quality of the crayons was useful: using a suitable brush dipped in clean water, I carefully brushed the crayon which blended and mixed. The tulip sketch was left as a crayon drawing, and no attempt was made to dissolve the crayon.

Starting Points

'I have absolutely no imagination': this is undoubtedly a cry from the heart! So what can be done? Why, develop it! It is very difficult, in fact impossible, to create something original from nothing, which is why artists are always filling sketch-books and notebooks with sketches, colour notes, colour swatches and things they have seen. This is also why a visit to some major art collection can be so rewarding. Any one of these can act as a stimulus and be the starting-off point for your next painting. Another solution is to paint what you see, and therefore to go out and paint. Failing that, paint indoors: set up a still life – a piece of pottery, perhaps – combine it with some flowers, and you have a starting point.

Most artists do build up a reference library of things that have caught their attention, or of pictures or photographs that intrigue them. Our world is so full of visual references that it would be a pity not to make use of some of them; they could be appropriately filed under the headings of buildings, people, skies and so on.

Using different marks on the paper can sometimes initiate an exciting new venture; the very idea of painting with a tool other than a brush can be the basis for different work. So consider experimenting with spatter and with resist, by making marks with pieces of cardboard, and maybe the other end of your brush. Blots were a starting point for Cozens, so why not you? Coloured paper or board, the addition of gouache or ink can all be put to exciting creative use.

Sometimes we come across a painting with a particularly interesting texture, or an unusual effect, and wonder how this was achieved. All artists must be prepared to experiment, and must not be afraid of failure.

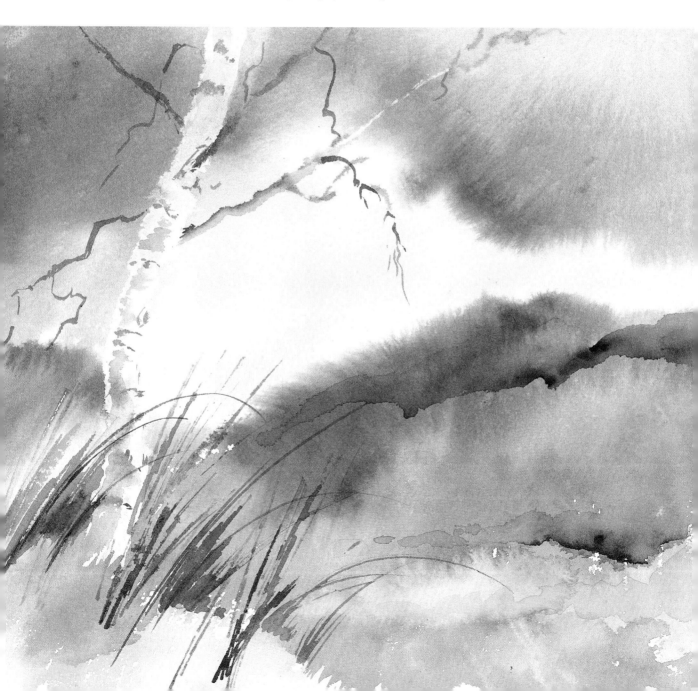

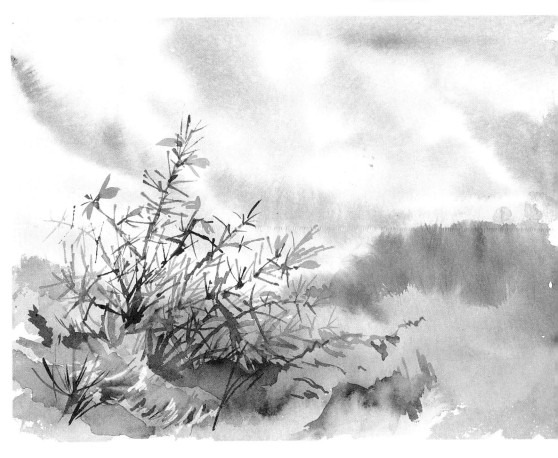

These two small landscapes were made with the intention of
experimenting with different materials. Based on a recent
walk over a heathy common, and with silver birch and gorse
for reference, I chose to work in two colours which normally I
rarely use: *Payne's grey and Naples yellow*. They formed the
basis of the idea (plus the fact that there was a storm raging
outside!), and I then used various wet-in-wet effects for the
sky, blotting out for the silver birch, brush marks, and marks
made with card. After some experimenting, this technique
was repeated for the gorse. It is an idea worth continuing
with, using different colours, and indeed some of these
experiments could easily be incorporated into other paintings.

(Overleaf) **Study of Gorse**
*This gorse study was made earlier and, together with an
actual piece of gorse, helped me to paint the more finished
landscape: this was a fairly simple idea of sky, foreground
and middle ground, with the gorse in the immediate fore-
ground, and painted in that order.*

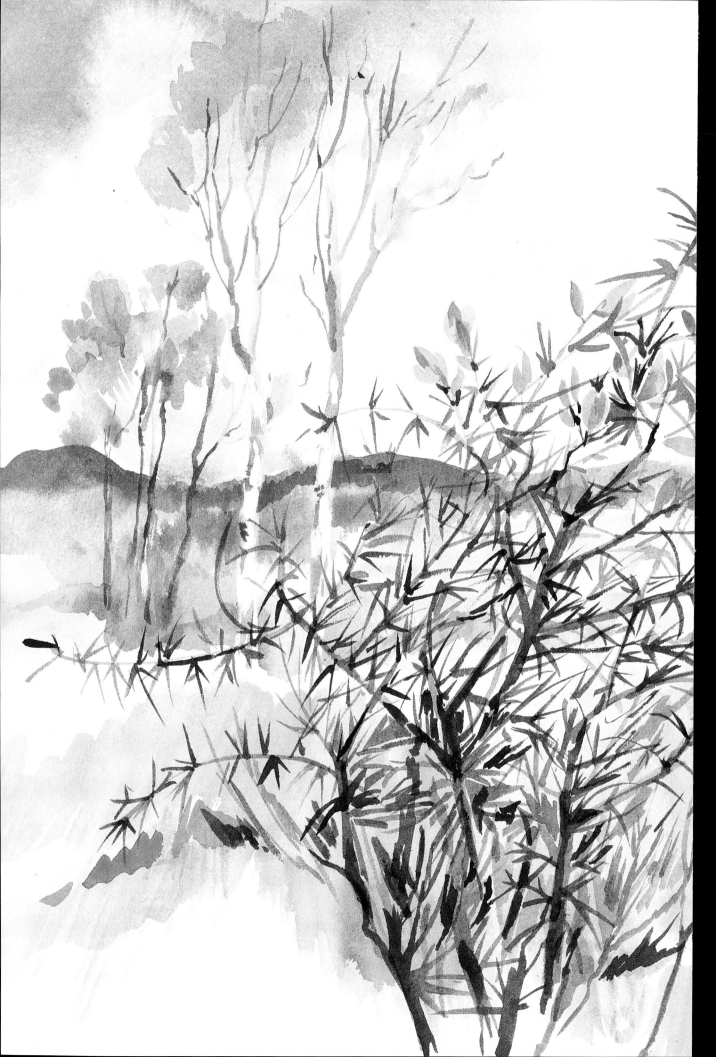

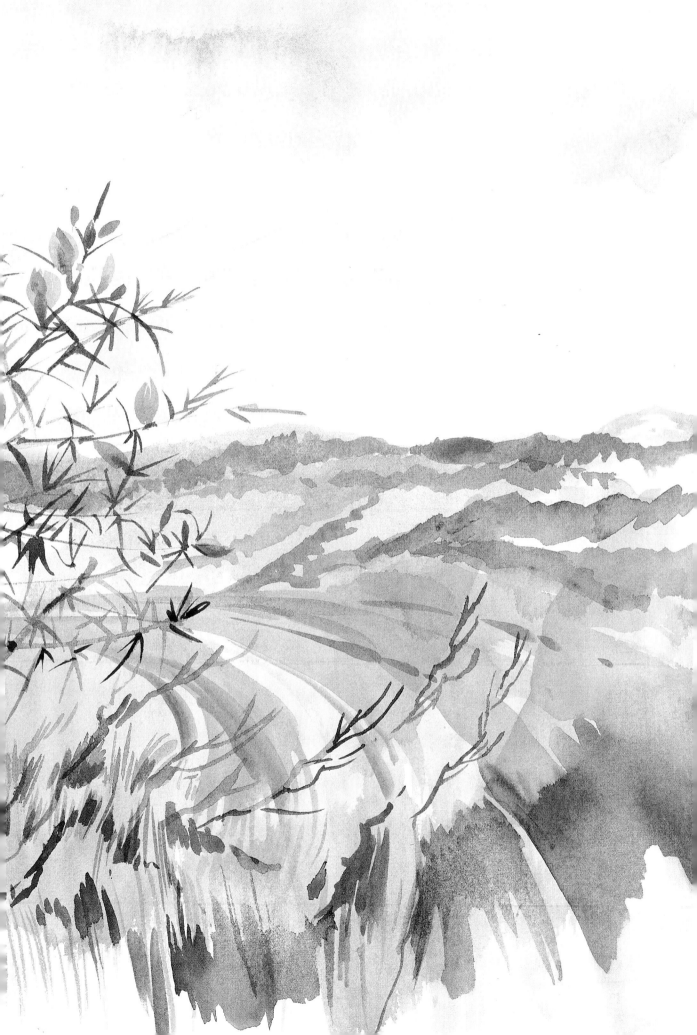

Experimenting

One way to start a painting when you are confined to the studio, perhaps because of bad weather or in winter, is to consider using references and sketches made earlier. Some people find this hard, and say they have no imagination to carry an idea through to the end. However, this way is a gentle introduction and can often be a spur to those professing little or no imagination. Having stretched my paper (a necessary part of this operation as it involves some very wet-in-wet painting!), I arrange my reference on an easy-to-see board; maybe I have some sort of idea already of what I want to do – perhaps something in my sketches.

In this case I wanted a cottage garden alive with colour and plants, foxgloves and poppies, and valerian . . ., and also to see if I could convey the feeling of a lovely summer's day – a tonic in mid-winter!

I therefore damp my paper and place some colour, pure colour, which will echo some of the colour in the final painting; in the instance illustrated I used rose madder,

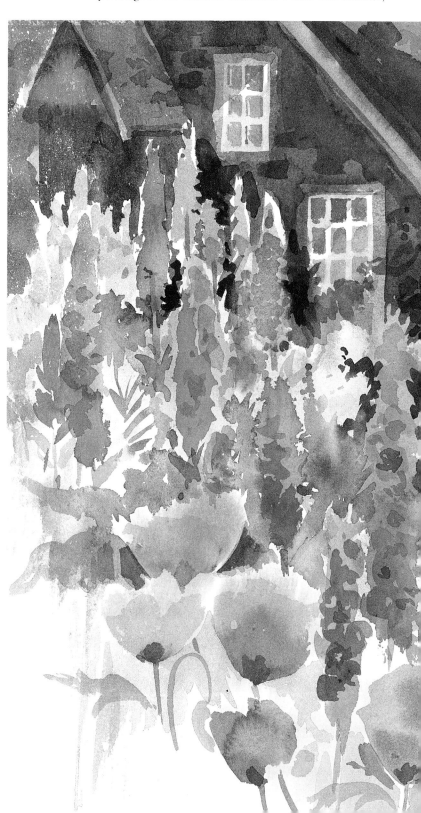

A Cottage Garden
This small study was the starting point for the larger painting which was based on memory and imagination. The strong contrast of the light flowers against the dark cottage appealed to me. Sketches like this can be stored and used months later to form part of a painting, or to provide the central idea for one.

aureolin, magenta and ultramarine. I then use darker colours, prussian blue and indigo, to indicate the distance, as I want my flower shapes to stand out well against a dark background. The colours will blur and fade and run; if I need lighter shapes I use blotting paper to lift blurred edges. I continue to define shapes as much as possible, having in mind my overall scheme. If the painting becomes too wet to handle, I let it dry off before continuing.

The idea of experimenting always appeals to me. There is nothing better than to have an open mind, with perhaps colour as your starting point. Maybe something you have seen recently could be the idea; combined with actual studies of certain flowers, and backed up with your reference library and a certain amount of enthusiasm, it could be enough. Many students complain of a lack of imagination, and the impossibility of starting. Imagination can be harnessed to many kinds of perceived images. On the television the most marvellous pictorial ideas frequently come across – try combining experimentation, imagination and subjects you have seen.

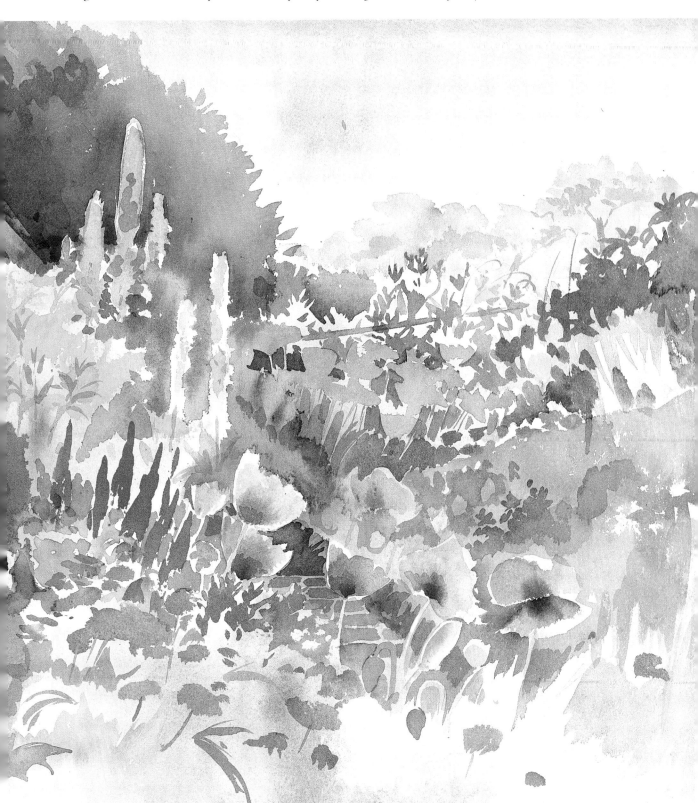

Using Contrasts

Contrasts of one sort or another are essential to good painting. It could be the contrast of different shapes, small to large; or textures, spiky to smooth; or of colour and tone. Often in good painting the observer is hardly conscious of contrast at all, just that the effect is exciting and pleasing in some way. Nature itself supplies us with good and subtle examples which, as artists, we should exploit. One which always fascinates me is the tracery of winter branches against winter sky; what a variety of line and texture! The lines are arching, or twisted and drooping, or thin with flat buds, and those are just a few! How can we convey the energy of line to our painting? A good exercise would be to use clean washes and an Indian ink line to convey a feeling of contrast in a simple way.

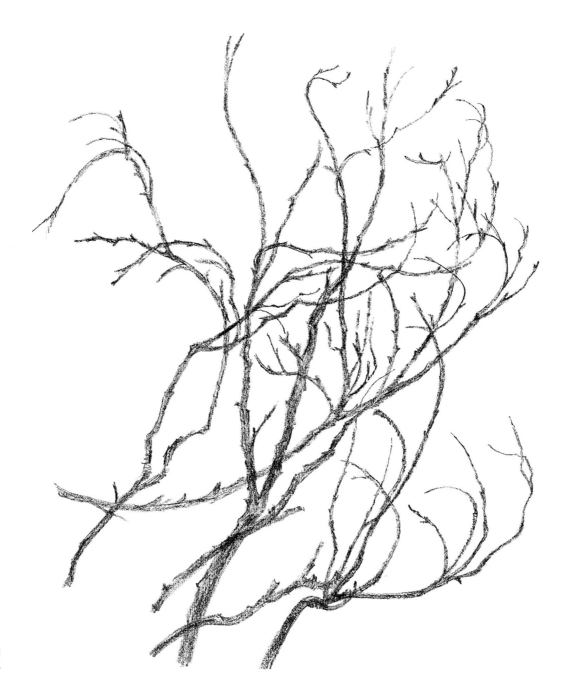

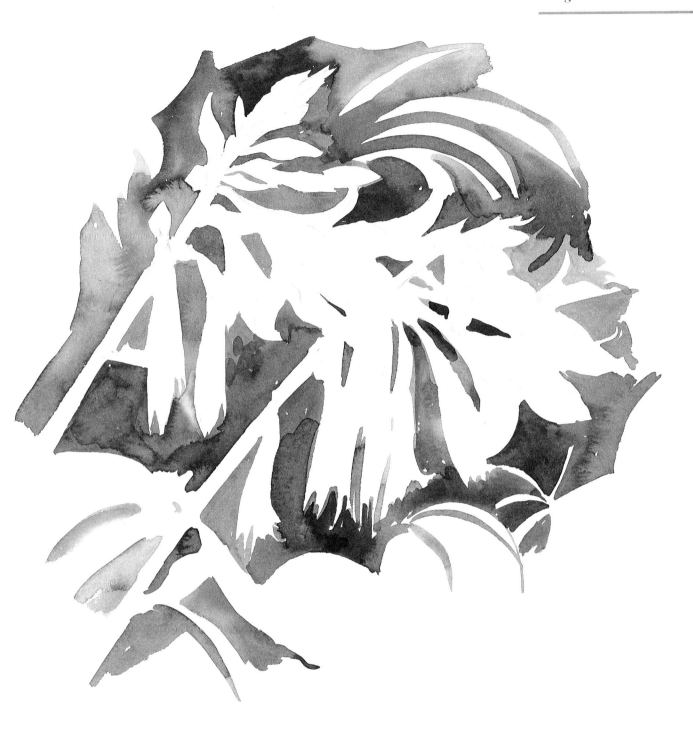

◁ *In this example we have several contrasts, dark lines against flat light areas, as well as dark tone against a light tone. Also playing a part are the shapes which the dark lines of the branches enclose; these are called negative shapes – and there is a certain difficulty here as the word 'negative' to me has always suggested dark shapes, where in fact many shapes made by a positive line or area can be called negative. These shapes are important and play a large part in your design.*

△ *This is an example of negative shapes, in that although these white shapes against the dark background are, in fact, hosta flowers, the dark areas not only comprise the background, they also delineate the shape of the flowers so that very little more would be needed to convey the idea of the subject. Thus we have here a contrast between light and dark shapes.*

I am always conscious of shape when painting, and become fascinated by the difference of one to another. The very character of one thing can bring out or emphasize the character of another, and it is these contrasts that we must be conscious of. I was particularly aware of this when finding these teasels by the river bank.

Seeing the teasels when out for a walk, and looking through them (they are quite a tall plant) at the river and landscape made me aware how extremely decorative they are. Tall, stately, but extremely prickly, they dry well and are useful to have in the studio along with reeds, poppy seed-heads and other dried wild flowers and plants.

The upright habit of the teasels contrasted well with the rather flat landscape around the stream. With individual plants I always find it worthwhile to make some studies first, as these help me get to know the character of each one. The tallness was a useful feature; so many plants are low-growing and therefore don't work too well with a landscape. Looking through the delicate tracery of the teasel branches can also be interesting, as the shapes between make a pattern. Small ideas such as this can form a platform upon which to base larger paintings.

Although this is a winter painting, tansy grows near here during the summer, another charming and decorative plant.

Starting with drawing can lead you into a painting. I usually use a 2B pencil on cartridge, or, as here, pen and ink. Very often you become so fascinated by the drawing process that the actual finished painting becomes an anti-climax!

Here, the idea was sketched in pencil before the subject, but because of the cold, the colour was painted at home, from memory; this is not ideal, however, as colour is so easily forgotten. Again, this was a fairly simple landscape idea and one that could be handled in different

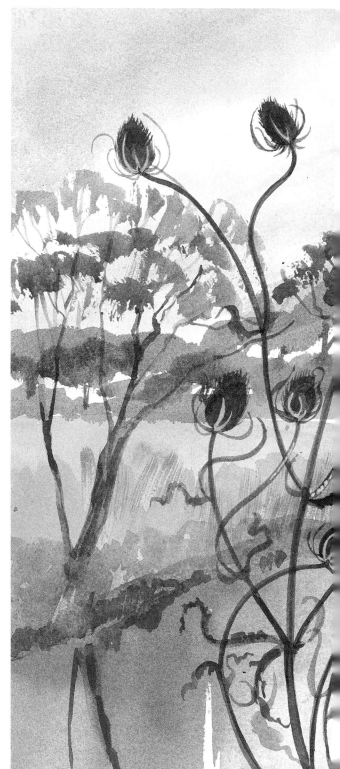

ways: first the sky was painted, then the middle and foreground, including the river, using simple flat washes. This was followed by the distant trees. When this was dry, some further washes were laid to indicate shadows and reflections and so on. Lastly the teasels were placed, using the reference sketched previously. This could be a small, medium or large painting, and it would be interesting to try different colour arrangements. However, the initial idea of contrast – the linear quality of the teasels and the flat areas of the landscape – should not be lost. Although this landscape was to some extent contrived, you should try to be aware of contrast when faced with the subject.

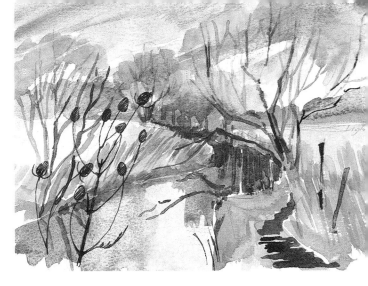

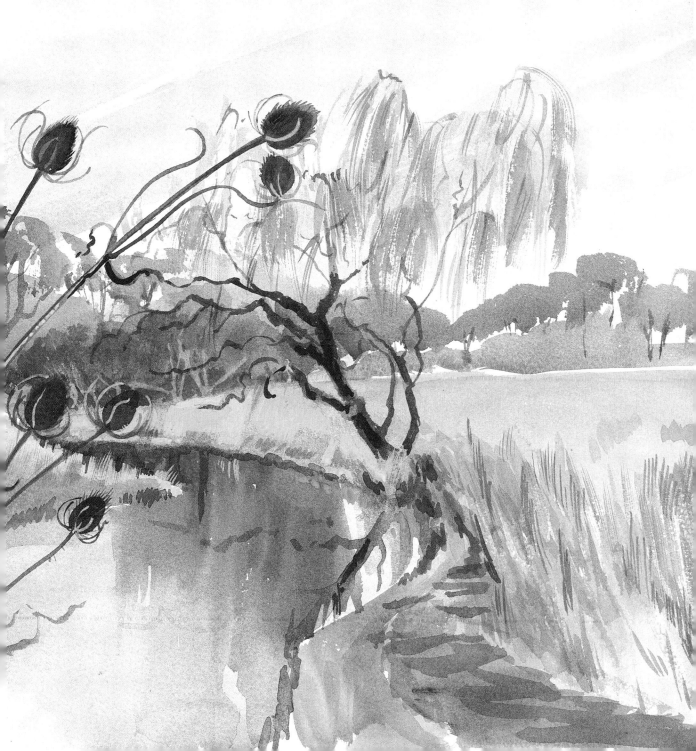

Shape

As well as the contrasting negative and positive shapes, we can also think of large to small – with flower painting this is important, as larger blooms can be complemented by smaller, fussier shapes such as small leaves and small flowers. There are many examples in nature itself. Contrasts can be exciting: you can contrast textures, lines and brush strokes – there are myriad ways to help make your painting more interesting.

Turner used spiky drawing in the foreground of calm watercolours. Toulouse Lautrec made vivid use of contrasting shapes. David Cox would use different sorts of brush strokes which gave his watercolours particular vitality. It is fascinating to identify for yourself the ways in which artists have used contrasts.

If your painting lacks vitality it is often because the eye is not stimulated by contrasts of one sort or another. Many landscape painters deliberately place a strong contrast as a

▷ *The Garden*
At certain times of the year, parts of my garden resemble a jungle and become a mass of leaves and flowers – but occasionally the light will strike one flower, seed-head or stalk, making it particularly prominent, and this is what I have tried to illustrate here.

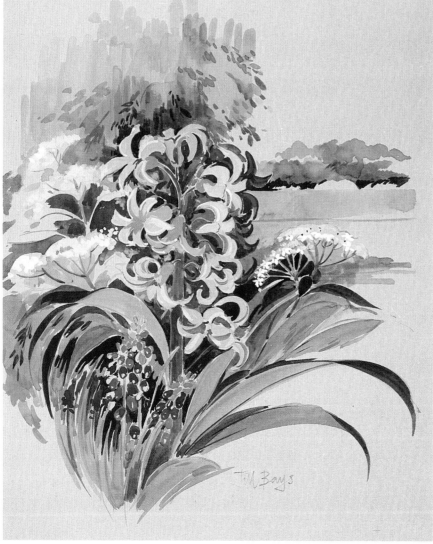

◁ *Hyacinth in Gouache*
This painting illustrates two of the points made: the first is counterchange, where the light flowers of the hyacinth contrast with the dark flowers, and the dark flowers with the light background. The other is the contrast of the smaller flower shapes with the large hyacinth flowers and leaves. If your work lacks vitality or is dull in some way, these points are worth considering to help improve it.

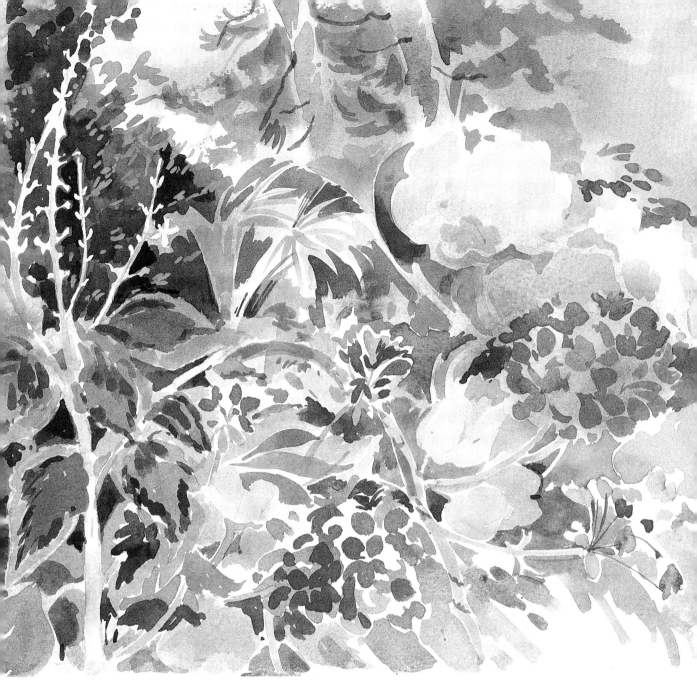

focal point. It could be the dark needle-point of a church spire against a light sky, or a particularly light tree in a dark painting. In the same way as all other artists, landscape painters also make use of the contrasts that light makes. Light plays a fascinating and important part in painting: not only does it illuminate, it also creates the very dark and light area that give us such contrasts. As artists we can deliberately control certain sources, but natural sunlight creates the most exciting and unusual effects – no wonder artists emigrate to warm climates! Light creates its own particular world of strong shadows against lights as fragile as white tissue paper; it forms unusual patterns where none existed before.

As well as capitalizing on the effects of light and its contrasting darks, we can make deliberate use of dark to light and vice versa by using counterchange in a calculated

way. Counterchange is to change to the opposite, to transpose; mostly it is used in pattern-making, particularly when colour is limited, for example black to white and white to black – a chequer-board floor is a good example.

Of course, when you are painting outside in front of your subject there are so many different things to consider – your drawing, time, composition, perspective – that yet another aspect could be one too many. It is a good idea to write a check-list somewhere (perhaps in the back of your sketch-book) of essential points to consider whilst painting, but if you get to an 'impasse', stop and reflect a while. Thinking and writing about contrast in painting has prompted me to point out certain facts that one should be aware of, but they should not be allowed to become too obtrusive or to spoil your enjoyment of painting – no one is going to get it right all the time!

Colour

In our discussion so far we have mainly concentrated on tonal and linear contrasts, and have not considered colour in a particular way. In fact we are often looking at contrasting colour; even now, as I am writing this in very early spring, three bright green parakeets are busy pecking at the pink almond blossom of the garden. Against a blue sky, the colour is amazing – I suppose tropical – and the contrast of the particular green against the particular pink of the blossom is exquisite. Some impressions stay in our mind long after we have seen them, such as the striking effects of sunsets – orange and blue, purple and yellow – and the brilliant colours of summer – yellow, red, blue. However, although as landscape painters we appreciate colour, often in transcription it turns out to be an uninteresting muddle of green. How can we avoid this?

There are various ways in which we can use colour to enhance our painting. I am presuming that you know your palette, and have no doubts as to the differences between raw umber and burnt umber, or ultramarine and cobalt! Also that you know how to achieve interesting variations of green, whether light or dark, or bright or pale; and that you know your primary colours and secondary colours, and which colour complements which. To refresh your mind, red, yellow and blue are primaries; and red/green, yellow/purple and blue/orange are contrasting and complementary to each other – and it is these contrasts which can provide interest and excitement in your painting. How much you use can be varied: for example a predominance of one colour idea is often better than equal amounts, but be careful not to use too much – too much red can overwhelm; it can be tempered by a cool green when the effect may be more pleasing.

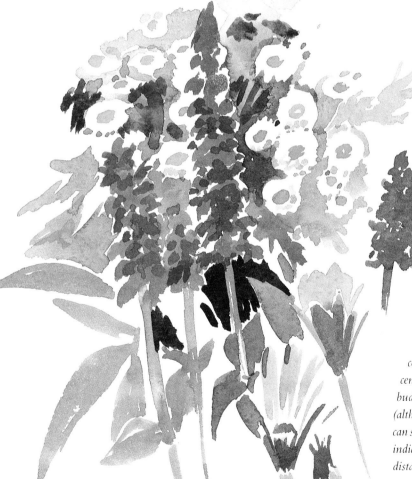

◁ *Small Flowers*
 Small flowers such as these grape hyacinths are often useful in larger paintings, but you have to find ways of simplifying them, because otherwise it is easy to become overwhelmed in detail.

▷ *Poppies*
 These shirley poppies come up every year in my garden and have been the subject of quite a few watercolours. The papery petals and easy shapes of poppies make them a favourite subject for artists, and the shades of pink and red are a perfect complement to green. However, it is often the muddle of stalks, buds and foliage which proves a stumbling block for many students. I would certainly paint the flowers first, starting with a central or predominant flower, then indicate stalks, buds and seed-heads with, perhaps, some leaves (although this depends on the plant). At this point you can start to fill in the spaces with other colours which could indicate further leaves, shadows, earth, sky or more distant plants. Once you have established the flowers, you can make your other ingredients follow certain compositional lines or directions.

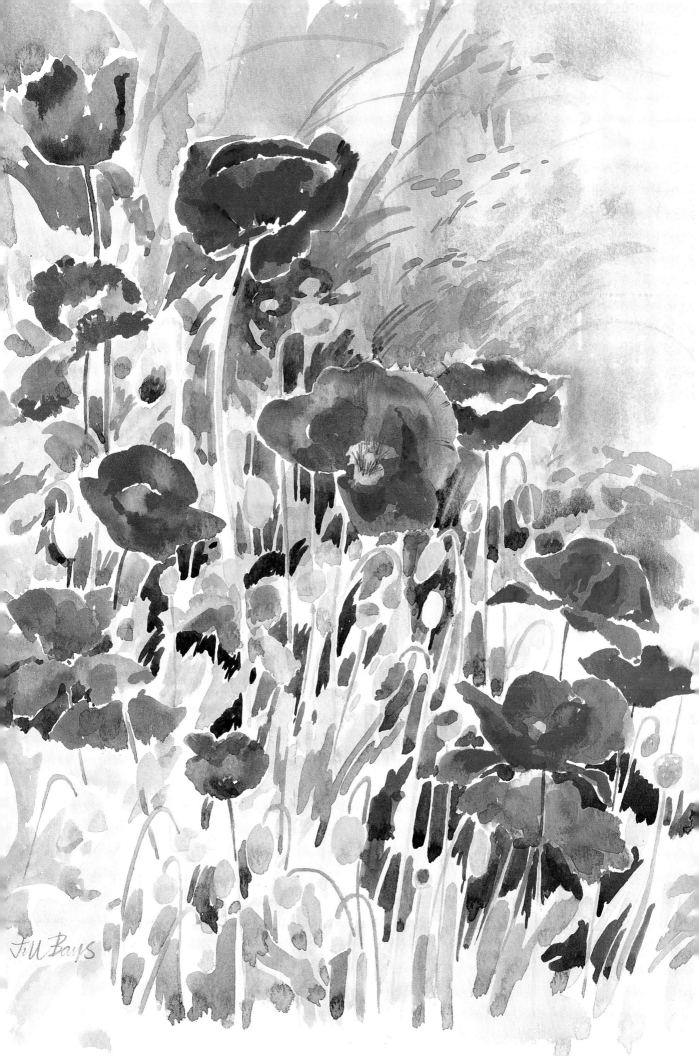

Complementary Colours

Nowadays one hears more and more about colour, particularly in relation to gardens. Too many colours can create a strident and harsh effect, but the careful use of complementary colours – for example blue, which is cool, and orange, warm – can be harmonious. Cool whites can be offset by warm greens. Colour is also exciting and can affect the mood and atmosphere of your painting. You can develop an eye for colour, particularly if you are aware of the various properties which it possesses. Time spent making samples, and learning to know which colours are transparent and which are more opaque will never be time wasted; discovering colour in this way can be particularly

helpful and may lead to some interesting discoveries.

Colour is all-important and underpins all paintings; if we didn't have colour, all our painting would resemble dreary November days – all greys. Colour cheers you up, it can give you a shock, it can make you sit up and take notice, or it can lull you into a sense of security and harmony. Red flowers can punctuate a green landscape, and drifts of yellow make you think of spring; blue is a heavenly colour, and blue flowers are highly prized.

In what ways can we make sure that our paintings sing with colour? One way is to use our paint in a very clean and pure way, and not to rely on the mud-like hues which lurk in every unwashed palette. Make a conscious effort to keep the use of earth colours to a minimum, and to

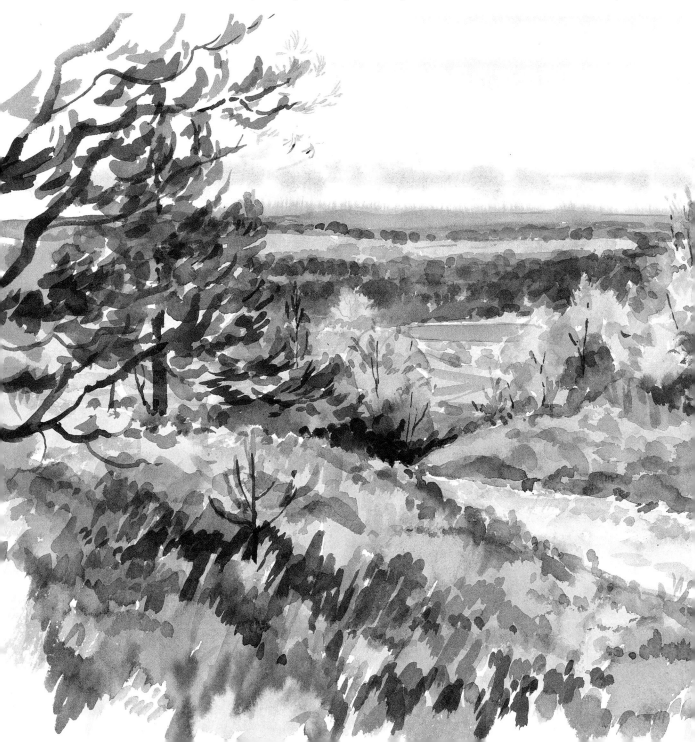

make greys and neutrals from mixing primary and secondary colours – in other words use broken colour or neutral colour, and do not mix more than two colours together.

Secondly, we could make a conscious effort to use complementary colours, and could search out subtle uses of these colours. Nature is very clever in this, and there are examples all around us: red apples on green trees, purple heather and yellow gorse, as well as all the myriads of flowers which never seem to clash however bright.

Colours seem to run in groups: for instance, a group of cool or cold colours could be tempered by the use of a warm colour; and a painting worked in warm or hot colours may be enhanced by the use of their complementary cool colours.

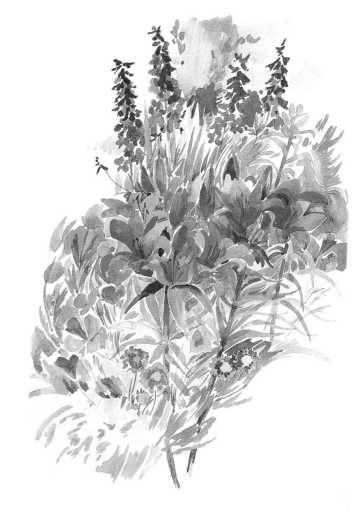

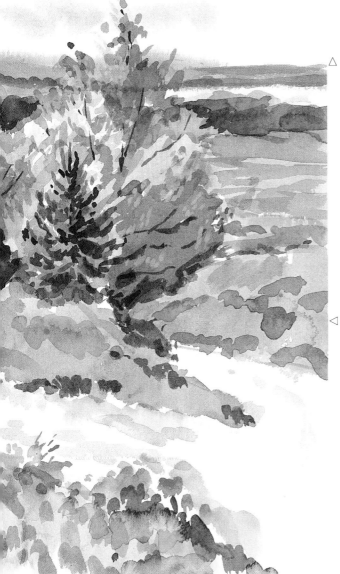

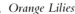

△ *Orange Lilies*
These brilliant lilies were growing against a background of blue delphiniums, and were just the right and natural complement to each other. The scabious and Californian poppies added to the blue/orange theme. The actual painting of the lilies needed a fairly careful pencil drawing to start with, as they were closely set and could have been a muddle; the leaves were also quite difficult and it needed patience to sort them out. The detail of the lilies contrasted with the freedom with which the delphiniums could be painted. This was quite a large work, 15 × 22in (38 × 56cm), and the lilies were approximately life-size. Large flowers such as these do make for easier painting; I would also recommend painting at an easel if you can, and certainly using a large-size brush.

◁ *Chobham Common*
This landscape shows the use of complementary colours, red/green or is it purple/yellow? Nature always seems to work out its colour ideas, and the heather blooming on the common was no exception. I liked the compositional idea of the path coming in to the centre of the painting, and the distant blueness of the Surrey Downs. Again, there was the problem of how to treat these masses of colour, and I chose a broad approach, starting with the sky and working all over the painting as much as possible. The light was constantly shifting and changing, so decisions had to be made regarding shadows.

A Knowledge of Colour

Having at your fingertips a knowledge of colour – how to mix and achieve colour – is enormously beneficial: ultimately it will become second nature and you will be able to concentrate on other aspects of your painting. To me it means, first of all, knowing the colours in your palette, knowing what happens when you mix them, their drying time, and also their drying qualities (allow for a 50 per cent lighter shade when dry).

The two colours which cause students the most concern are greys and greens. There are various ready-made greys – Payne's grey, neutral tint, Davy's grey – which can be useful, but I prefer to make my own; these can be warm or cold, and there are various mixes you can try: ultramarine + burnt sienna, ultramarine + brown madder, ultramarine + burnt umber, cobalt + light red, cerulean blue + cadmium orange.

With regard to greens, again there are ready-made greens available, from hooker's green to sap green, but all need modifying in some way with, perhaps, earth colours such as burnt sienna and raw sienna. I usually work with light, medium and dark greens with the addition of blues, browns and yellows as needed. By light green I do not mean a watery version of the medium green, but a definite, clear green full of pigment.

There are many ways to achieve your light, medium and dark green and getting to know your palette will help, but you can try prussian blue and cadmium yellow pale for light green, prussian blue and yellow ochre for medium, and prussian blue and burnt sienna for dark green.

With regard to the many colours you can have in your palette, I myself find it useful to have just certain basic colours: the three primaries (red, yellow and blue), plus a few earth colours, plus one or two pinks, and prussian blue. My palette therefore consists of Winsor yellow, ultramarine and alizarin, crimson, yellow ochre, burnt sienna, brown madder and rose madder. Other colours which are useful for flowers are magenta and Winsor violet. I have often set myself exercises in colour which, while being quite personal, often lead to interesting experiments. For instance, try painting with just the three primaries, or the complementary colours, and leave out the earth colours. Note the results – you could be surprised! There are many facets to colour, including transparency, opacity, and whether they fade or stain. Some people are fascinated by the granulation of various colours, and certainly ultramarine has this quality when mixed with burnt sienna. Most suppliers have charts as to the qualities of paints, but on the whole it is experience that is important.

Often the addition of a new colour to your range can spark off different ideas, but on starting out the fewer colours you possess the better. Do experiment, and get to know the properties and individuality of whichever colours you possess. I have concentrated on green in particular in my examples, as many students find it so difficult. Green is often a predominant colour in both landscape and flower painting, so it is wise to be familiar with its problems. However, this is not to say that there are no other colours which you need to study; yellows and reds are important as well!

In the course of study, and painting, a knowledge of colour will come naturally. Furthermore there are many ways in which you can change your ideas of colour: for example you could turn the whole idea of green on its head and paint its complementary colour instead. Or change your green (or whatever colour you like) to something else, which could create a more subtle and interesting variation; for instance, change greens to a blue-grey and work from there. There is really no limit once you get started!

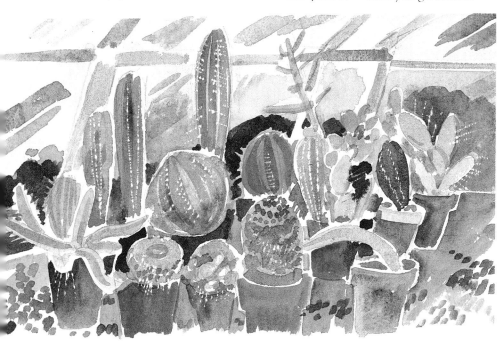

Cactus
This small sketch of cacti in a greenhouse illustrates some of the different greens that it is possible to make: yellow-greens, blue-greens, dark and light greens, dull green, mustard greens – you should be able to recognize the various colours which go to make up this variety.

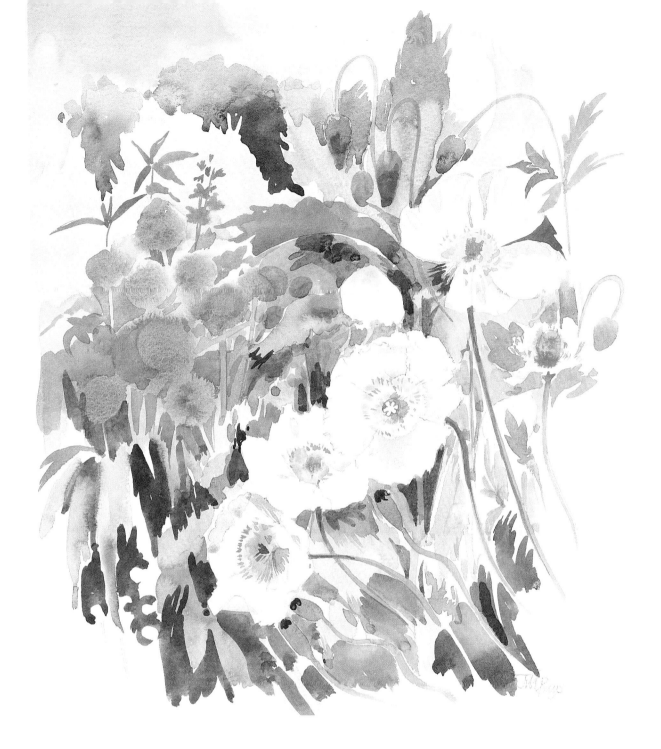

Icelandic Poppies

This painting also illustrates the various greens which can be obtained by mixing. Furthermore you can see some of the subtle greys used on the poppies themselves. Painting white flowers is always a challenge, especially when they are as delicate as these, with petals which drop off before your eyes at the slightest puff of wind. Again, when starting, the poppies are lightly drawn in pencil and painted first, before the background. In fact I generally paint what I see, rather than make anything up, so that the globe shapes of the echinops in the background are actually there. You can see here quite definitely the dark, medium and light greens which form a background to all other green mixes.

*(Overleaf) **Dahlias***

This painting was inspired by the yellow and purple dahlias, and the way their warm colours contrasted with the cool greens and blues of the background, the white daisies emphasizing the colours. It was painted when it was hot, with willows and apple trees in the background, and an attempt was made to capture the feeling that it was a windy day, too. The colour was laid in wet drifts across the page, yellow, greens and blues, with small spots of Winsor violet for the purple dahlias.

CHAPTER 5

Creativity

'I don't know what to paint,' is a cry which I often hear; but in painting it isn't necessary to have grand ideas in order to be creative. Start in small ways: take a bunch of daisies and put them in the light on a window-sill, and then explore different ways in which to tackle them. Maybe creativity will come from the medium; there is a wide choice of materials today, and once started you will see that there are many possibilities.

Learning a craft is often a frustrating business – you achieve so much, and then seem to stop making progress, an impasse which can only be overcome by hard work, practice and intelligent observation. Exploring the possibilities of applying different media to the same subject can be rewarding. Sometimes when you are started on a painting you realize that you are tackling the subject in the wrong way – so start again, because you must feel happy about what you are doing.

As well as being able to choose your subject successfully, it is also an advantage to be able to get everything in the right place, particularly when trying to dispense with a pencil. Drawing your subject takes time if you are inexperienced, and if you spend too long drawing you will have no time for painting. Watercolour painting is for me an immediate medium, which captures the moment. In our busy lives today there is often no going back to the subject; and in any case, the light will more than likely have changed and will therefore throw you out completely. Flowers are notorious for moving, or dropping petals, so be prepared for spontaneous, accurate work. In laying down the basic washes (which often have no boundaries) you must place the items correctly.

The worst part about being creative is actually getting started, though once you have managed to begin, further ideas do present themselves. Nevertheless, the initial sheet of pristine white paper can be daunting! Some people start by doodling, or copying, or going to classes, or joining a club.

The more you build up ideas in your head, the more you will have. Exploring relationships with colour is one way, filling your sketch-book with colour swatches, sketches and ideas is another. Being open to new ideas is important, and looking at other artists' work can often be a starting point.

Working directly with a brush teaches control and is more spontaneous – often sketches look better than the finished result. On a small scale there is no temptation to put in unnecessary detail; you can improvize and be less inhibited. When translating your sketch to a larger size it is easy to lose your initial enthusiasm, but with your studies and sketches you should have enough material with which to work.

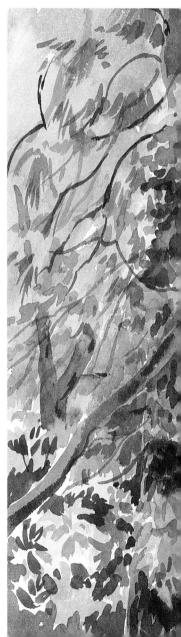

An Idea for a Painting

Much of the time, ideas for painting present themselves fairly easily; scenes can be remembered and certain elements made up from sketches. For example, cycling along the lane near where I live, I noticed a light green willow reflected in the river, a small white boat, and a pink blossom tree framed by an ivy-covered tree. On arriving home, I made the colour sketch opposite as quickly as possible, realizing that my remembered observation was far from adequate! So studies of an ivy-covered tree were made in pencil, and studies of water and rivers were fished out, until I felt I had enough background to work with. Surely it would have been easier just to return and paint in situ? Well, sometimes it simply is not convenient: the cars rush by, the part where you want to stand is under water, the weather is not inviting – and so one works from sketches. Painting is demanding since a fair amount of thought and work has to be put in before results can be obtained.

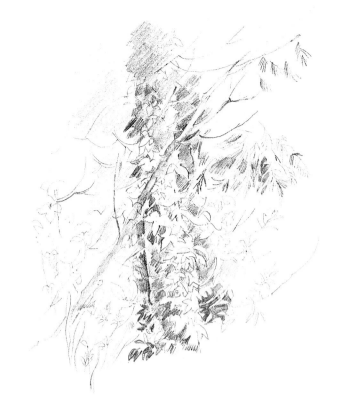

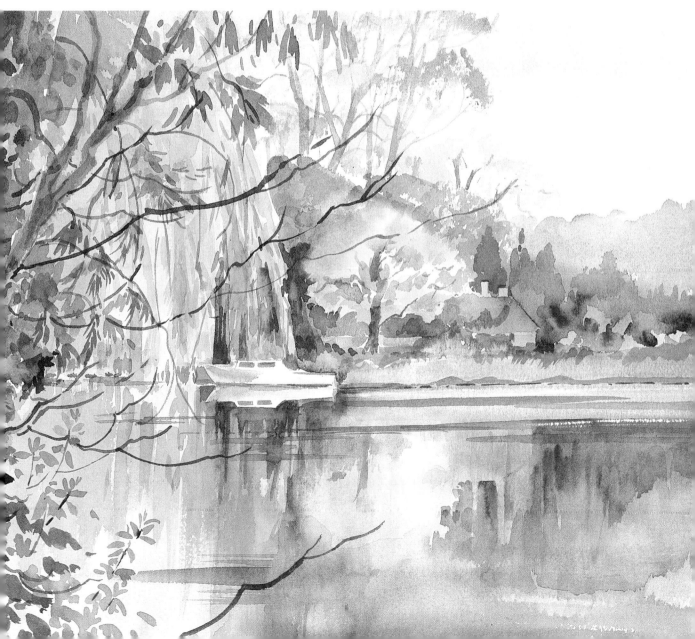

Composition

What is it that constitutes a landscape? Artists who paint landscapes are attracted to them for various reasons besides a love of painting! There is the appeal of the open air, of painting nature as it is and not second-hand; there is the idea of putting something on record, whether this is for posterity or to help recollection of a particular place at a particular time – bluebell woods spring to mind, holidays and romantic associations.

I have often compared those artists who paint 'plein air' to fishermen who have the same compulsion to get up early and go off to inaccessible places, and who often go too heavily laden for comfort. Similarly, while you don't want to find you have forgotten your brushes, it is quite possible to limit the materials you take to a minimum; thus apart from my easel and drawing board, I fit all my materials into a fishing bag (there's the comparison!), along with camera, sketch-book, stool, spare sweater and hat. The actual painting materials are palette, paints, brushes, water pot and bottle, kitchen towel and blotting paper. With regard to paints, it is surprising how few colours you need and it is quite possible to limit them to primary colours only: yellow ochre, alizarin crimson and ultramarine, with maybe prussian blue and burnt sienna as additions.

Many of the paintings shown here are paintings of gardens, and these are what might be termed 'enclosed' landscapes. Often landscape is associated with open vistas, with undulating or rolling hills, and to incorporate flowers with landscape more often than not suggests gardens of one sort or another. On the other hand, nature itself suggests so many subjects: for example berries and autumn leaves, and many, many wild flowers, all of which provide ready-made subjects for the painter.

It is sometimes quite difficult to adjust immediately to a new subject, and familiarity with your surroundings is best – a long, slow, getting-to-know kind of familiarity, so that you have time to evaluate and decide on possible composition and colour. However, the excitement and stimulation of fresh surroundings is hard to beat!

Different artists have different ideas about composition, and there are many rules and theories. It is obviously a good policy to have a focal point to which the eye is drawn, and this can be achieved by directional lines, colour and shape. Sometimes a simple shape or sinuous arrangement works well; as with most things, experience is important. Maybe the painting is successful just because of the way it is done, or because of colour, drawing and execution!

However, there are certain points which you could bear in mind regarding composition. One is to be careful

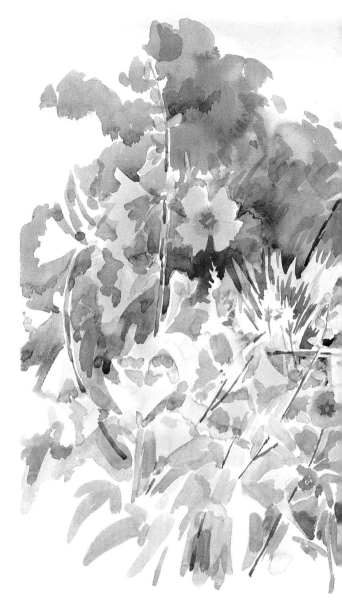

not to halve your painting, either vertically or horizontally; it is very easy to do this, even while quite conscious of the fact that it is not advisable. It is better to divide your picture area into thirds, or to have some sort of guiding structural lines running through it – a diagonal is an obvious choice, or an S-shape, or an L-shape. Empty centres should be avoided. On the other hand, there are no rules to be broken, and it seems that today anything could be right!

The right kind of preparatory work is helpful, as it is most annoying to find that you have made elementary mistakes when a painting is nearly finished – but these things can happen to the most experienced artist, even when preparatory sketches *have* been made. I suppose, ideally, you should think for ten minutes and draw for five, and be prepared to repeat your sketches if you feel they aren't good enough.

Other factors concerning composition are being aware of recession, and perhaps creating a centre of interest, a

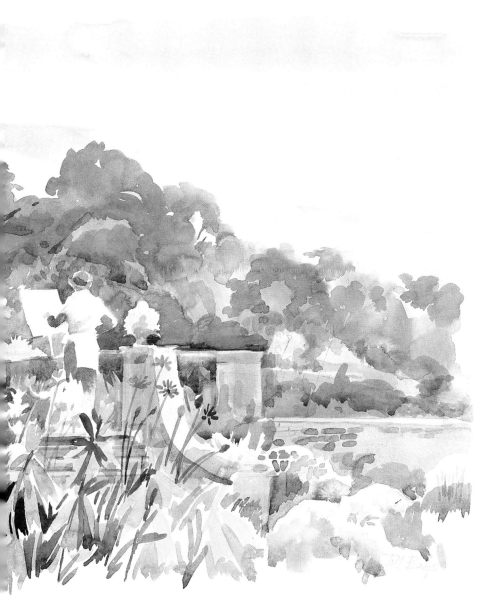

An Artist Painting
This is a good example of having a focal point – a centre of interest. Although the main idea of the composition is diagonal (reiterated in the line of the pink flowers, the steps and wall and the line of the trees), the upright figure and easel and the other verticals balance and hold the diagonal, as well as being a focal point.

▽ *Bluebell sketch*
This sketch provided the study which enabled me to paint the larger bluebell painting. Although captivated by the 'blueness', the scent, and the overall beauty of the wood, the subject was approached in a straightforward way: first the sky, second the bluebells, then the foliage and trees and the shadows, and lastly the darker areas and various details. The trees warranted more study and care but time ran out, and the light changed quite quickly.

focal point; this could be some kind of important contrast – light against dark, for instance, of colour contrast, or shape contrast, which will focus the eye. The idea of light against dark is the most important, introducing the feeling of depth; and achieving enough depth is quite difficult, particularly when using watercolour.

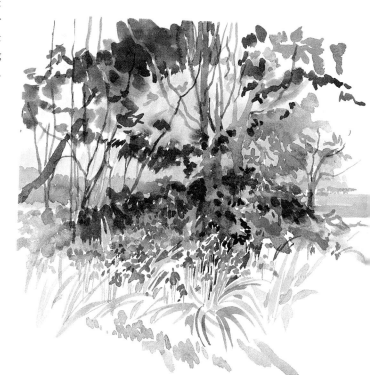

(Overleaf) **Bluebells**
At the end of April the bluebell woods in Surrey are a delight, but difficult to paint. However, they are a good example of flowers in the landscape! Of course, it is difficult to assess how much detail is needed, but I feel it is always better to observe areas of colour as a mass, and approach detail later. (A super-realist's point of view could be quite different.) I am more concerned with a general immediate impression; in this painting it was the lightness of the blue against the dark foliage.

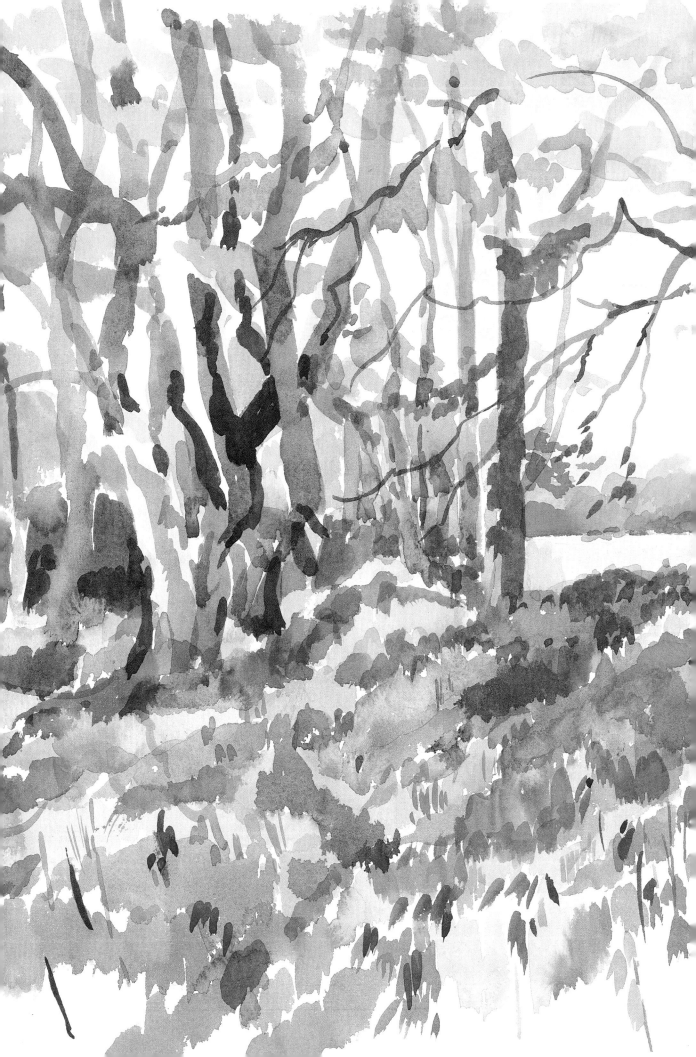

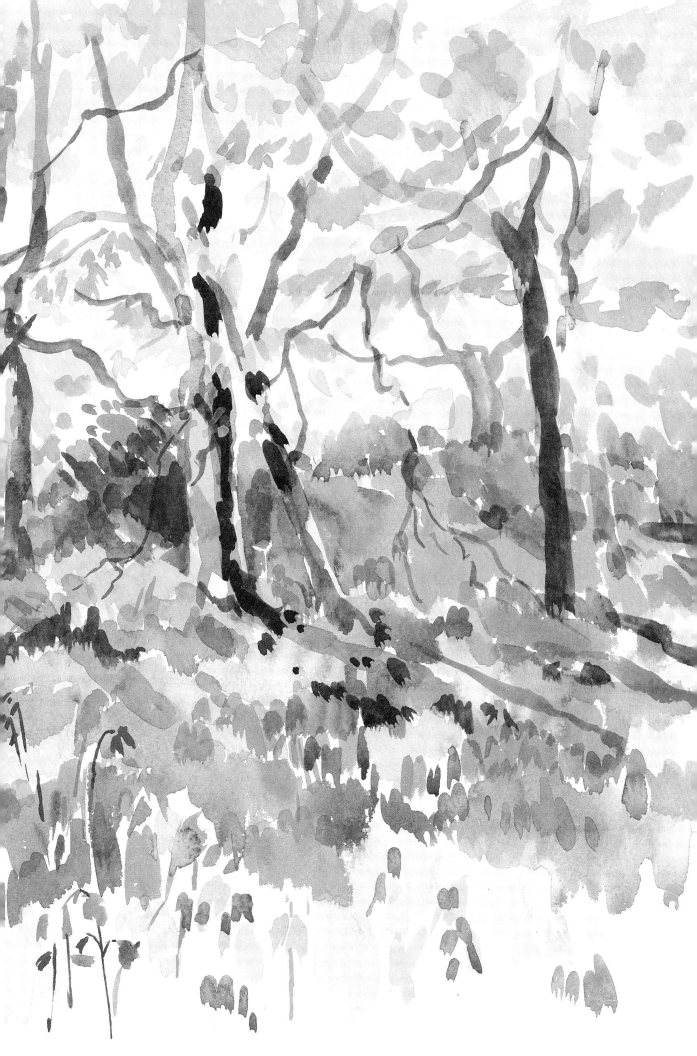

Achieving Depth in Watercolour

Watercolour is associated with transparency of colour, with delicate washes and delightful blending of pigments when used wet, but depth of colour is also needed, and this is often quite difficult to achieve. One reason for pale colour is the use of hard colour in pans; fluid colour in tubes is easier to handle. Black is often found in watercolour boxes, but is really superficial to your needs (maybe if painting a black boat?). Dark colour is obtainable by mixing, and you can find a blue, green or reddish tone according to your ingredients.

When looking at your subject, try to realize the very darkest tones, and the very lightest, perhaps noting the depth of colour on the edge of your paper – your other tones will be falling between the darkest and lightest. Your dark colour can be achieved by mixing burnt umber, prussian blue and crimson alizarin, or ultramarine, burnt umber and crimson. Very dark greens can be obtained by mixing burnt sienna and prussian blue. Indigo and Payne's grey are useful as well. Note how the colours dry; they always look darker when wet, but dry considerably lighter. Working in strong sunlight necessitates the use of strong shadow colour, and it takes practice to get the depth required.

A Corner of the Garden
For a brief interlude the light struck these geraniums and illuminated them against the dark cedar tree. In my painting of them the brightness was helped by leaving a white rim around the edge of the flowers, and I also found that I had to darken the background quite considerably after the painting was completed. I often find that to put a painting on the easel and to glance at it occasionally in the following days helps me to look at, and consider, various points such as tone value and composition. You may not have time when painting outside to consider everything; it is often difficult to complete a painting of this size in under two-and-a-half hours, so that further appraisal is often necessary.

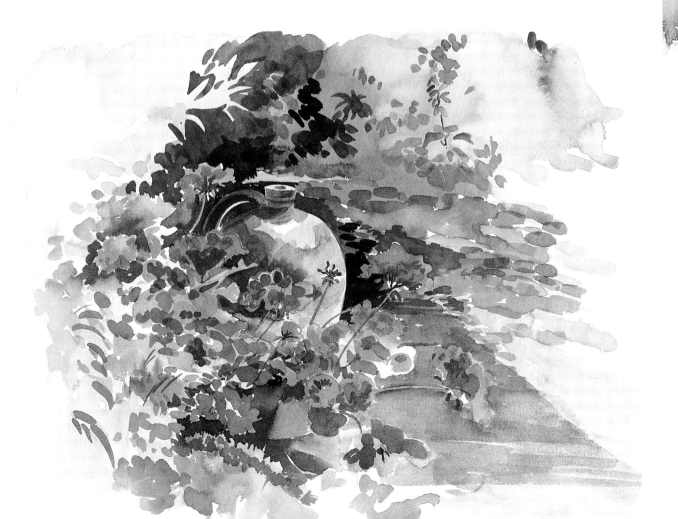

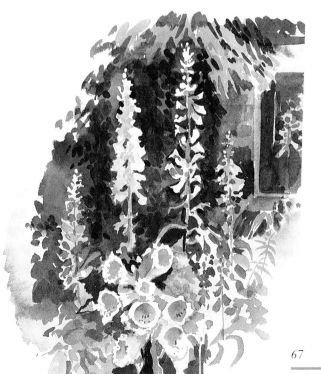

◁ *Geraniums*

The main focal point is the geranium on the right, pink against the dark shadow, and the dark shadow prominent against the light pot. The eye is drawn to this area first because of the strong colour contrast, and also because the taut line of the pot edge contrasts with the rather more uneven edges of the flowers and leaves.

▷ *Foxgloves*

These foxgloves literally sparkled in the sunshine, but it was with difficulty that the darks were achieved and overpainting was needed. Although the very dark green looked incredibly dark when painted, I was surprised to see it dry a lot lighter, and in fact I had to use Payne's grey as a last resort. A week later these foxgloves had been blown over by the wind.

67

Painting Flowers and Making Studies

Painting flowers is harder than you think. Most flower shapes are fairly small and require a reasonably steady hand, whatever type or style of painting you prefer. I am not writing particularly of botanical painting here, which is certainly a more studied and scientific way of describing flowers, seeds, leaves and so on. There are fashions in painting flowers, just as there are certain popular ways of doing many things. However, although it is difficult to resist certain trends, the best approach is the straight-forward, honest one which seeks to describe the subject in a personal way. There are no short cuts, and a thorough grounding in painting is necessary. Flowers are so lovely, so pure and colourful, that most of us are unable to resist them; moreover painting flowers is an opportunity to use those marvellous colours which are mostly denied us when painting landscapes – all those lovely pinks, magenta and yellows can be indulged in and enjoyed.

Start by drawing the basic shapes, recognizing the ellipses and cones that are the basic shapes of many flowers; be quite precise, and let a carefree approach come later. When you are confident in your drawing, start painting, using your brush to describe the shape, the petals, and the

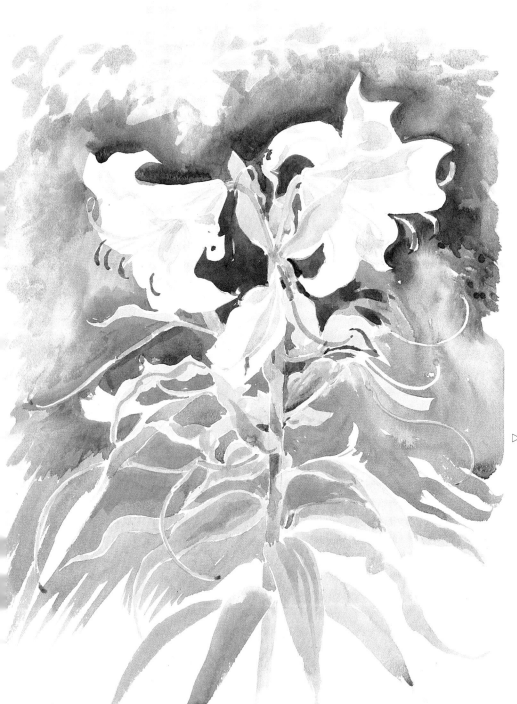

◁ *A Lily*
This handsome lily was nearly over by the time I went to paint it, but the long pistils and stamens helped to make it rather decorative. It stood out against the dark green hedge, making a very bold statement. It was painted the actual size.

▷ *Daffodils*
A small study in pencil and wash on a smooth paper. Daffodils are notorious for being difficult, the shadow being very elusive – you can't decide if it's green or grey, so here the pencil helps to provide the tone. Using a pen seemed too hard for such a delicate flower.

way the light is falling. Light is very important; even on a dull day flowers turn to the sky and the underneath parts are in shadow, and painting in brilliant light is often quite difficult, particularly semi-transparent petals.

In the little painting here of a hellebore, the light was from above, making the inside of the flower darker; this creates the shape. With so delicate a flower, the darker background was essential. In the carnation studies (see p. 73), a delicate change of colour indicates the direction of light, while a few strokes of darker paint show the underneath of the frilly petals.

In the studies illustrated here, some are recognizable as flowers and others are exercises in using the medium. Large flowers are easiest as they have the broadest shapes; certain flowers are best avoided by being too complicated or too difficult a colour. Many-petalled flowers such as dahlias and chrysanthemums are fairly hard, and very small flowers are, to my mind, best kept for incidental inclusion or as background interest. It is useful to have available, and to be aware of, the various leaf shapes. Yellow flowers are tricky, and combined with green can become sickly. White flowers are fascinating to paint, as you can forget colour and concentrate on tone and shape.

I find that if I want to get to know a flower, the best way is to draw and paint it from all angles. The important thing is to practise, practise, practise!

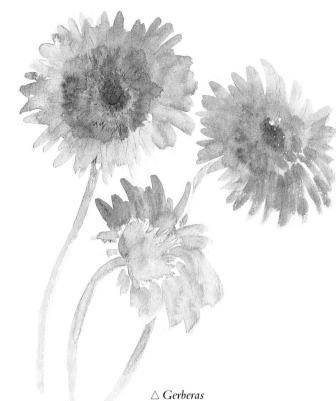

△ Gerberas
These exotic many-petalled flowers belong to the humble daisy family. Before starting a painting which contains a flower I am not sure of, I often make studies such as this in order to get to know it better, and to decide on colour and shape. In this case the colour was rose madder genuine, a delightful transparent pink as lovely as its name.

Hellebore
The shape of this flower is like an upturned bowl.

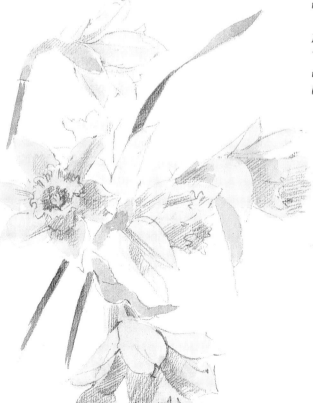

(Overleaf)
A Victorian cottage garden with foxgloves, and Jacob's ladder making an informal frame.

69

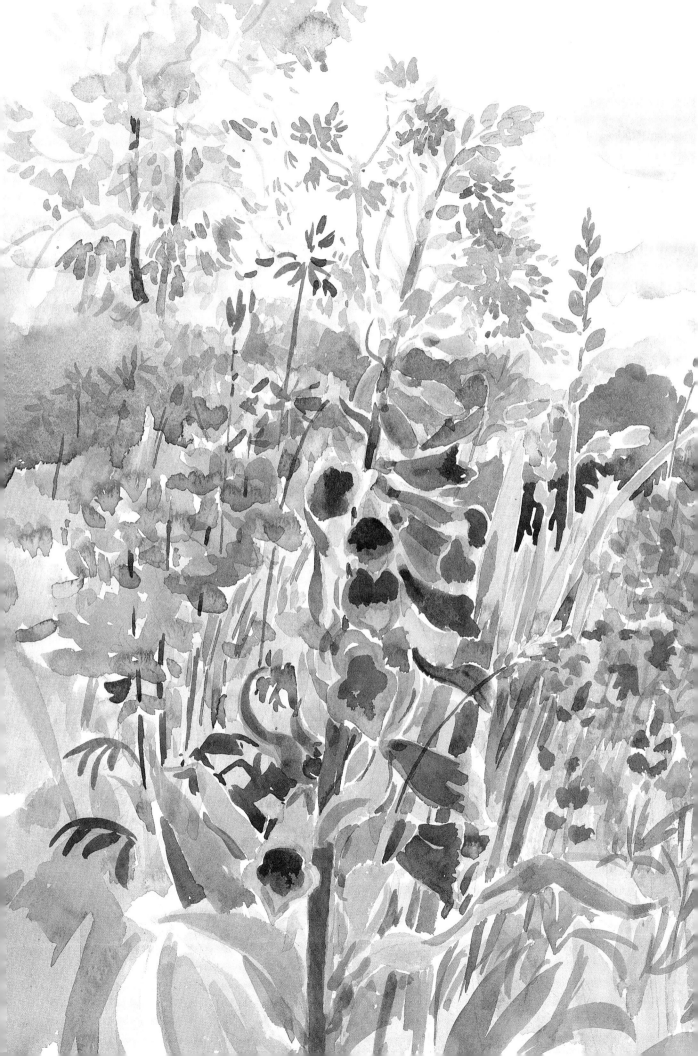

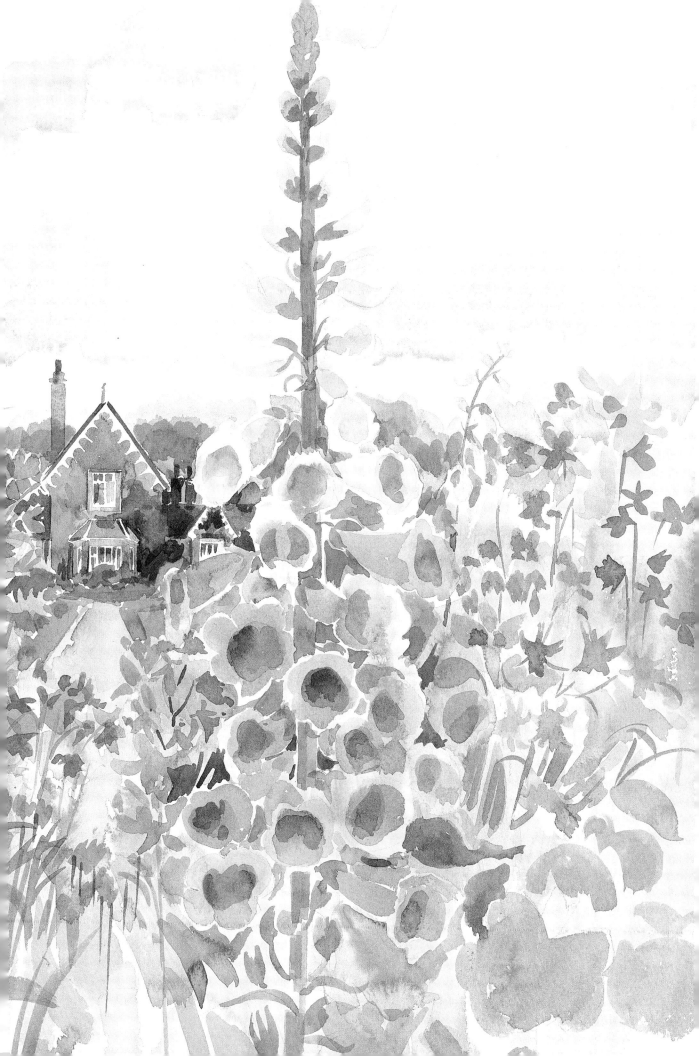

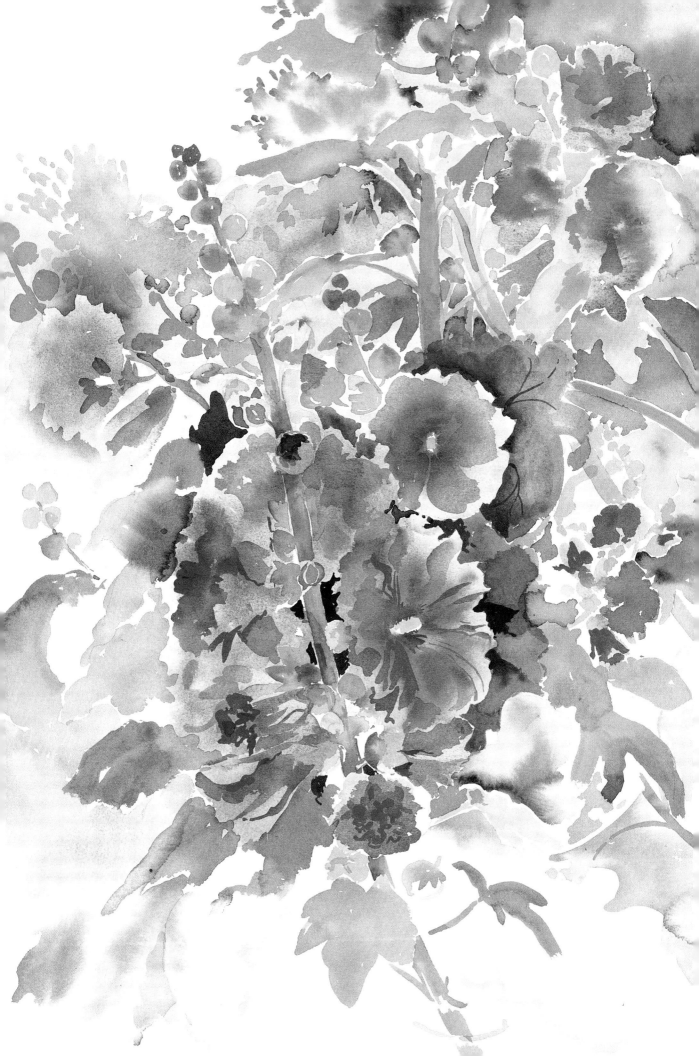

Hollyhocks

This painting of hollyhocks is an example of part study and part painting. Showing a simple background in a neutral colour, it is one stage on from a study.

Hollyhocks are enormously tall, and if painting them life-size you can only paint a part of the plant. You will find fully-opened flowers, buds, partly-opened flowers and leaves all on one stem. This hollyhock was double, with large frilly petals; there were others which were a deep wine red, but not so easy to paint inasmuch as the colour would be difficult to achieve.

In tackling this as a study, I started with the flowers on white paper, adding the other hollyhocks and grey background later. The subject suggested an upright painting. I started with a slight drawing before painting, using rose madder as my base pink, and working on one flower at a time. To achieve soft edges I worked wet-in-wet, only adding folds and frills when the base was dry. The stem and leaves, and further flowers, were placed next. Not a great deal of thought went into the composition at this stage; it was afterwards that the pale grey background was painted. At the time the afternoon was overcast and grey, and this suggested the hue I used; thus the actual colour was Payne's grey, which is quite a warm grey yet neutral – mixed with a little pink in places this seemed to be right to indicate and suggest bushes and trees. Hollyhock leaves are rather nondescript, floppy and dull, so I didn't emphasize these. An enjoyable afternoon's painting – I must remember hollyhocks for next year!

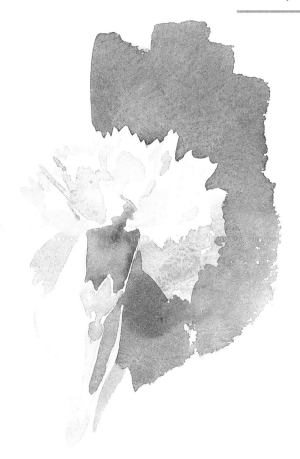

Carnations
People are often given carnations, and because they are so lovely, want to paint them. They are, however, rather frilly and delicate and the deeper shadow tones are difficult to find.

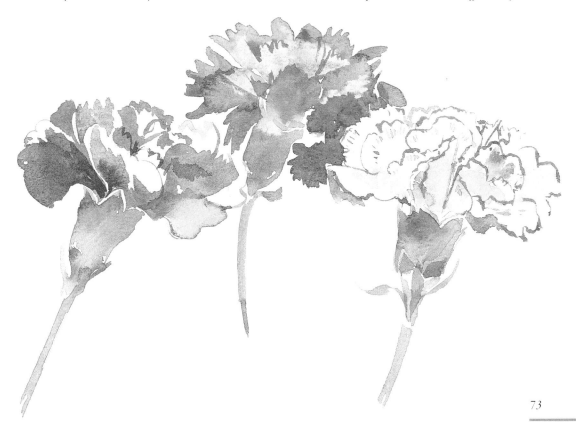

Combining Flowers and Landscape

Landscape

Painting outside is fascinating; almost anything can be a suitable subject, and when flowers can be combined with landscape there is no end to the possibilities. Even as I sit writing, I can see a delightful composition through the window: poppies in the foreground, with poppy seed-heads, in the middle distance a fence, gate and hedge with elderflowers, and in the distance a light-coloured field; a subject all ready-made! All around us are possibilities; these might comprise water and sky, trees, fields and plants, as well as buildings of all kinds, walls, statuary, seats and so on. It is up to us, then, to be able to convey these onto paper in whatever medium we prefer; though to do this successfully it is important to have studied the various components – skies, water, foliage and trees.

Sometimes the study becomes the painting, sometimes not, but one thing is certain: your efforts are never wasted. What is meant by studies? It is a kind of pictorial note-taking, when you gather all kinds of information which may help you in the future; they may concentrate on colour, drawing or tone, and any kind of subject from just one tree to perhaps compositional studies which could be a preparation for a larger work.

Studies of figures can also be made to include in a landscape. This is particularly helpful given that people are rarely still and it is often difficult to capture just that right attitude when working on a painting.

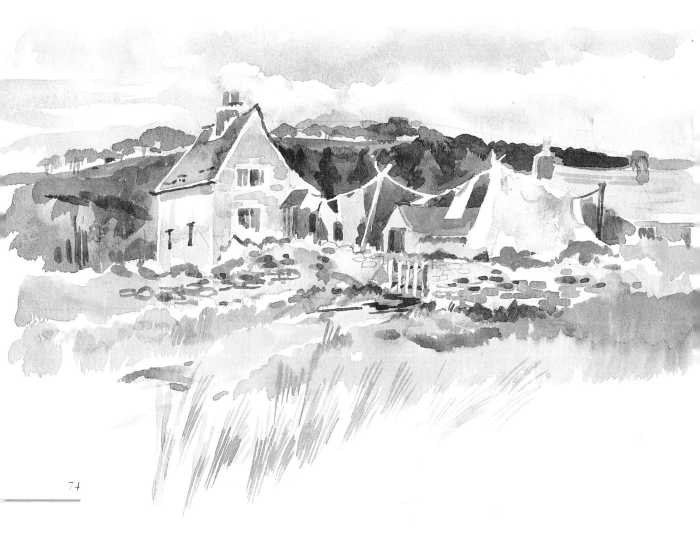

▷ *Sheep Grazing in Yorkshire*
The hills in the background were painted in 'body colour', that is, watercolour mixed with white, as I found it very difficult to achieve a feeling of distance and solidity in pure watercolour. This was a sketch-book painting and has since been translated into oils. A conté crayon was used for the detail on walls and roof.

▷ *Gloucestershire Landscape*
I found it difficult to decide exactly which way I would look, and initially made a small sketch with the tree on the left; however, I then changed my mind and decided to tackle the landscape from this direction. This aspect turned out to be more satisfactory, resulting in a more 'finished' landscape; basically it was a very straightforward painting, and a good example of foreground, middle ground and distance. There were no buildings to complicate matters, and the foreground grasses were interesting. The sky was almost bleached out as it was a hot day.

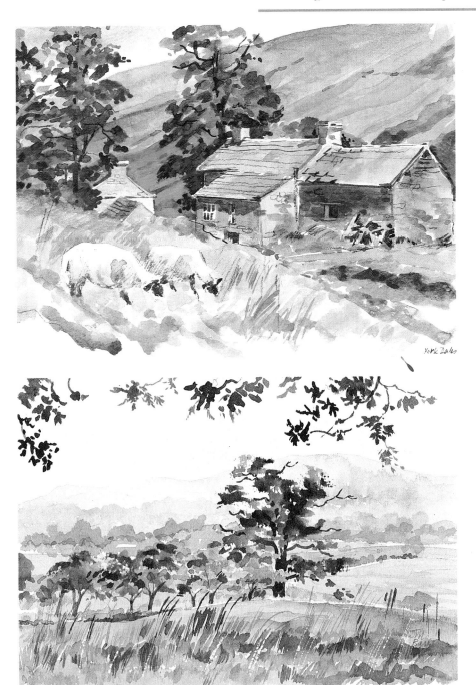

◁ *A Cotswold Sketch*
This cottage at Sapperton is perched above quite a deep valley; when I first saw it, I was particularly interested in the garden with its vegetables and flowers, but found that unless I peered over the wall I couldn't see the garden at all as it was on a slope. I therefore settled for the longer view, and here the foreground and the washing provided the interest.

(Overleaf) **White Daisies**
Occasionally garden flowers will be found growing handsomely in uncultivated situations that gardeners would be envious of, and this combination of garden escapes and areas which have been left to nature always intrigues me. These white daisies were found in a neglected garden, and the way they grew side by side with wild grasses and plants and in an untamed landscape fascinated me. Using various references and photographs, I compiled this painting, trying to keep it as fresh and direct as possible.

75

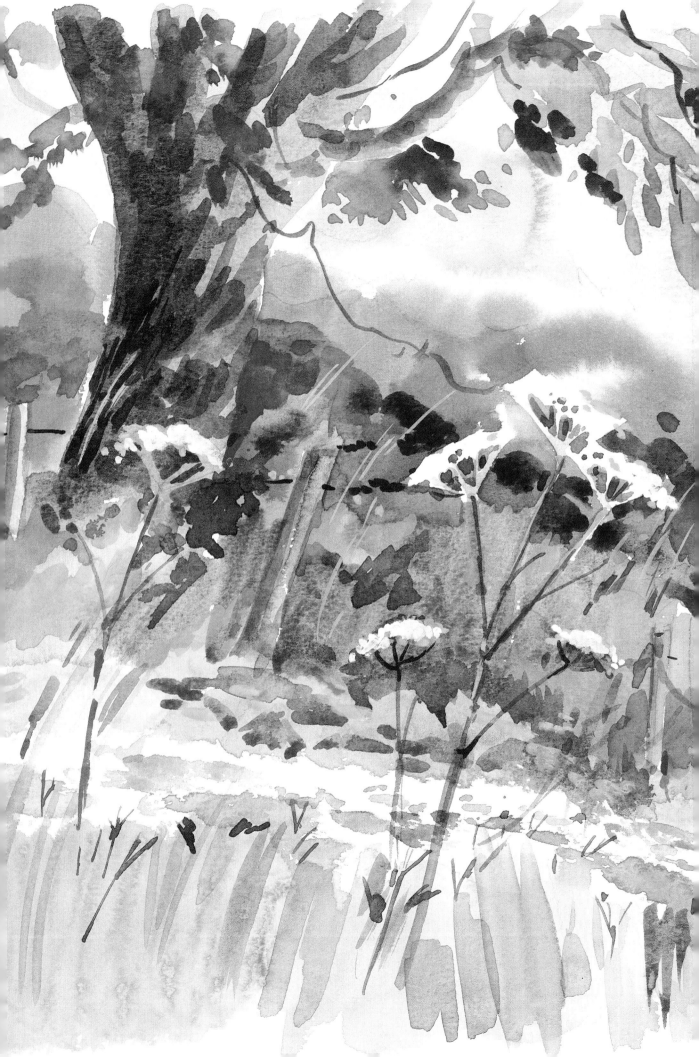

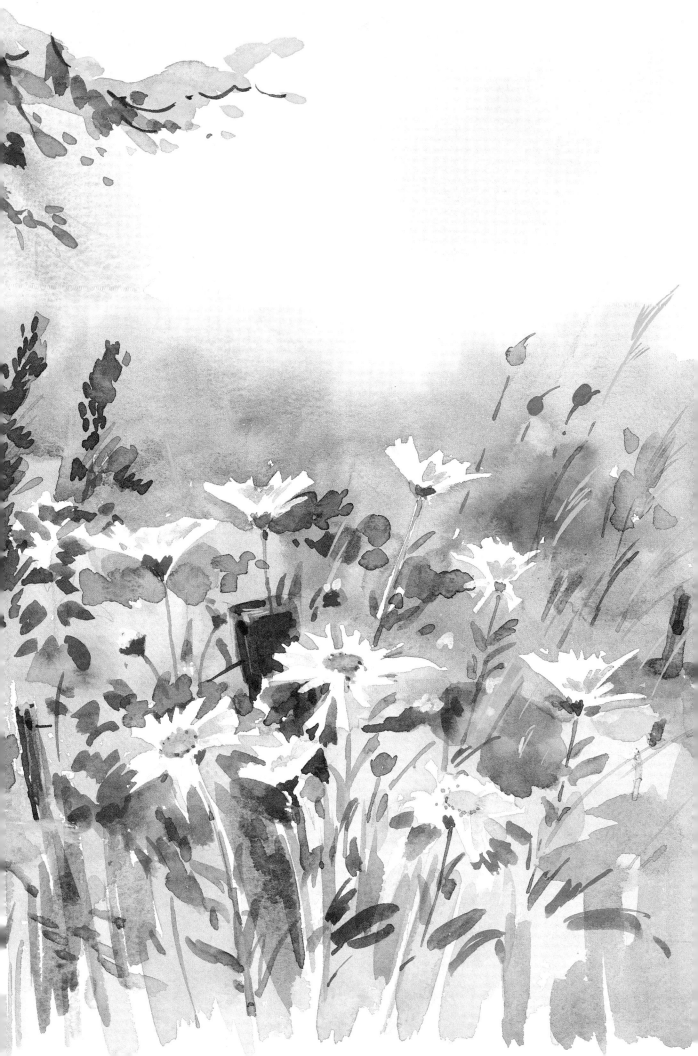

Painting Skies

Observation is all-important, and building up a diary of skies in your sketch-book helps enormously; this, plus photographs, will provide your basic reference and will also give you confidence when you are actually confronted with the sky itself.

For simple skies you should be quite capable of painting a flat gradated wash, and then a colour gradated wash, although practice is needed for more complicated clouds, whether the fine day variety or storm clouds. You should know the differences between the various blues – cerulean, cobalt and ultramarine – and to know indigo and Payne's grey. Cerulean blue is a cooler green-blue, while cobalt is a true clear and transparent blue; and ultramarine is a stronger, warmer blue which granulates when mixed with other colours. Indigo is a dark, inky blue, whereas Payne's grey is more of a grey-blue. These various blues can be combined with warm colours – brown madder, light red, burnt sienna – to make greys. Take care when indicating a yellow sky, and if your sky has a yellowish streak towards the horizon, make sure you let your pale tint dry thoroughly – if you don't, it might end up green! A good yellow to use is raw sienna, as it is transparent. Mixing a warm or a cold grey should be second nature.

Cloud formations are useful to know, as for example, a basic knowledge of the difference between cumulus and cirrus. And when you come actually to paint your sky, it's a good idea to know if your paper works better damp or dry, or indeed if, when painting outside, the temperature permits damping. In the middle of winter it is often necessary to paint the sky last, or even at home! Certainly, practice pays off, as you need to become sure of yourself. Quite a good maxim is 'Put it down and leave it', as no amount of messing around trying to make improvements seems to work.

Skies – Studies
These are three of the many cloud and sky studies that I've made; I'm not sure of formulas, but there are certain ideas that I use often. Cobalt is a gentler blue for the blue of a sky, but I will sometimes use ultramarine and brown madder to make a warm grey for clouds. For a cold grey – for example, for more thundery clouds – I would probably mix ultramarine with burnt sienna.

Skies 1
From a sketch-book, a free interpretation of a windy day painted on dry paper using ultramarine, cerulean, brown madder and raw sienna.

Skies 2
Another sketch-book sky study on damp paper using cobalt, ultramarine and brown madder.

Skies 3
A really dramatic sketch of an April sky in the Cotswold countryside, using ultramarines, some cerulean and a cool grey mix of ultramarine and burnt sienna.

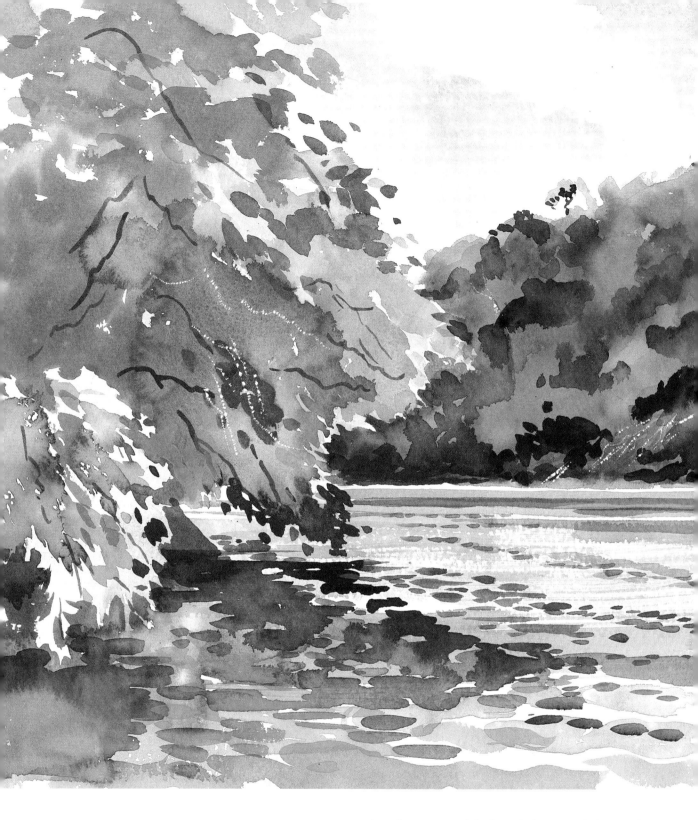

Painting Water

Water can have many moods, and the still, sunlit pool is quite a different proposition to a rippling river or to the sea. Thus water can contain reflections which are a mirror image of the bank; or, if disturbed by the wind, it may be full of movement and contain no reflections at all. Painting the sea demands special attention, and warrants study on its own. Studying the subject you want to paint always

has advantages, and the knowledge you gain is never lost.

Painting water and reflections has a certain abstract quality, and you can work away happily without worrying about realism; it is also an ideal opportunity to practise wet-into-wet! By making studies of water in all its moods and situations – rock pools, streams, lakes, harbours – you will improve your technique and painting vocabulary by leaps and bounds. Make a point of noticing if the water is darker than the sky, or if the colour of the sand or bed

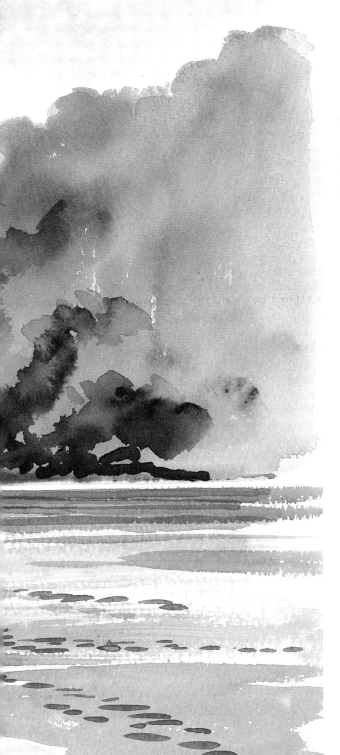

The Estuary

The tide was in when I started to paint, and the water was changing all the time – there were patches where the surface was smooth, as well as ripples caused by a slight wind, and eddies made by ducks and the odd boat. In this sort of situation it is important to decide on a certain approach: in particular with water, it is easy to lose direction because it changes so constantly (it also rained), and you want to avoid overpainting if you can. This was painted on a rough paper which was ideal for dry brush work.

plop of a fish. There were several different things to portray here: the distant trees, the areas of lily pads, and the water which was extremely dark because of the earth colour of the bed and its shallowness, plus of course the reflections. The distant trees were mainly silver birch, and a light pale green in colour – these were painted over the pale cobalt sky. The lily-pad areas were put in next, using a lighter, brighter green; these areas allowed me to paint the tree reflections in a somewhat darker green. (The green used was a mixture of prussian blue, yellow ochre and cadmium yellow pale; different amounts of these colours were used to achieve different tones.)

Occasionally the tone values in a painting need adjusting; in this example the waterlily leaves were a bright fresh green but tinged with reds and yellow, and some of them reflected the sky on their shiny surfaces. If painted the colour they were, it would have been quite tricky to have judged the tone of the water, which reflected the light silver birches on the opposite bank; the colours therefore needed to change slightly, to give lighter lily pads and darker water.

With a landscape subject such as this it is easy to get lured into trying to depict too much detail, as the eye can take much more than it is possible to paint. In any case, time is often limited by outside factors as well as changing light (the lilies had closed after two hours).

Another factor was the need for recession: in fact this was a good chance to appreciate the idea of foreground, middle ground and distance.

(Overleaf) **Waterlilies at Gracious Pond**

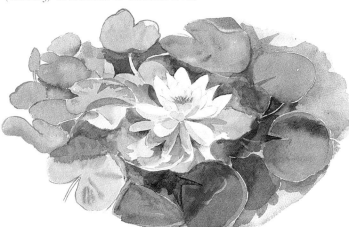

affects its colour. A variety of brushes can be used to draught out the shapes, though a square-ended wash brush is probably most helpful. Painting water is a marvellous opportunity to run through the whole range of brush strokes and techniques which are available to the artist.

The most striking feature of the scene overleaf was that the water surface as depicted in this painting was perfectly still. It was a very warm day, and the only movement seemed to be the flash of blue dragonfly and the occasional

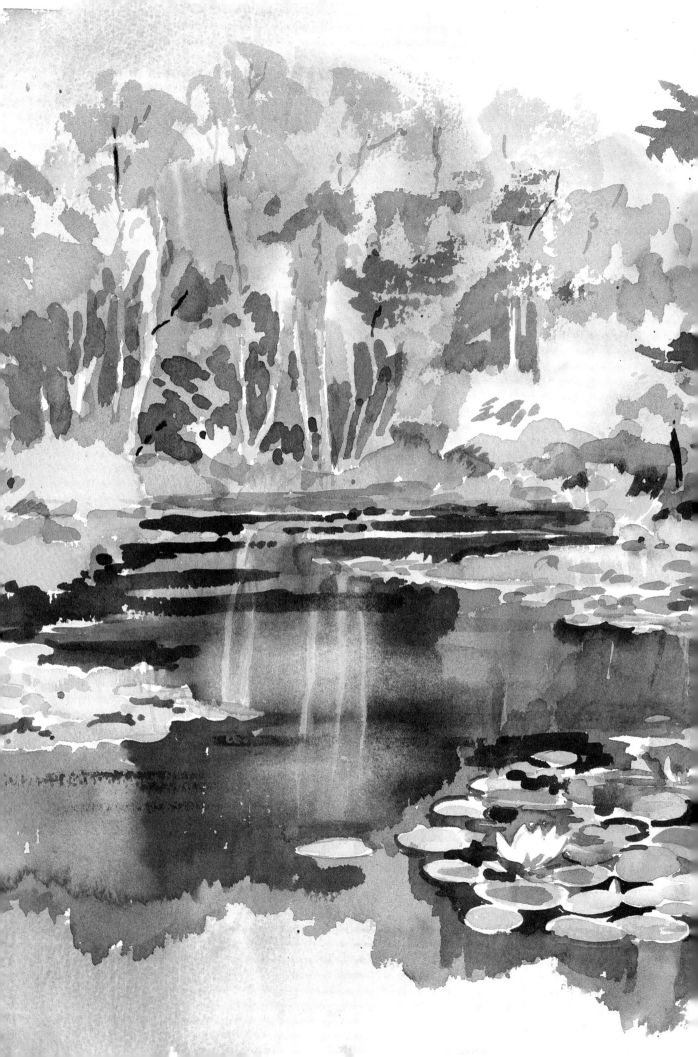

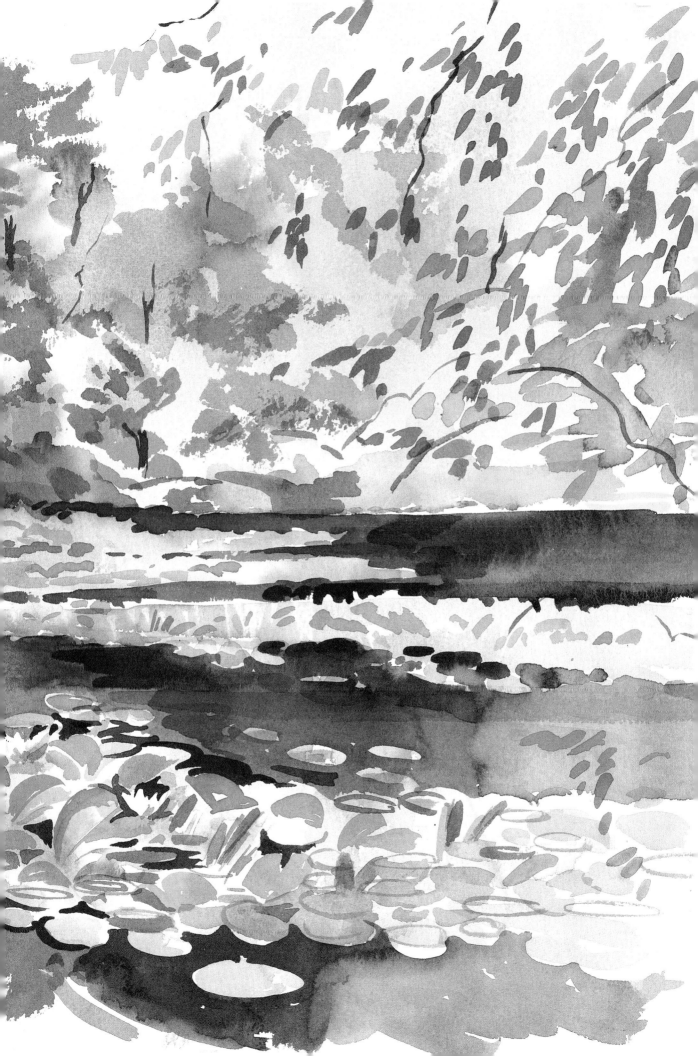

Painting Trees

Trees feature a great deal in my paintings, probably because I am surrounded by them, living in a low-lying, very fertile river valley. There are oaks, ash, silver birch and most deciduous trees, and also conifers of all types. Trees make a delightful dark background to light-coloured flowers, and present us with the whole range of greens in the summer – so much green that it is easy to forget the attraction of autumn colours, and that winter trees have their own charm.

As with painting water, one of the most valuable things is practice, as is a knowledge of shapes and habit, of whether the leaves look up or down, or are large or small. Tree trunks are fascinating and can be grey, brown, pink or green, twisting and turning, or strong and straight. As an artist, you will become more and more aware and observant of many characteristics that were never noticed before. Generally I find that my light, medium and dark greens are in constant use, and that it helps to keep my washes fluid. I endeavour to capture the character of the tree, and so could employ various materials to help me: thus I have a small, stiff brush which I fan out in order to describe the tops of distant trees, my sponge has several uses, and a sharp conté pencil is good for delineating certain branches. Leaf shapes require practice, and certain brushes are more helpful than others. Depicting the silhouette of leaves at the edge of a tree can quite often convey its character and type.

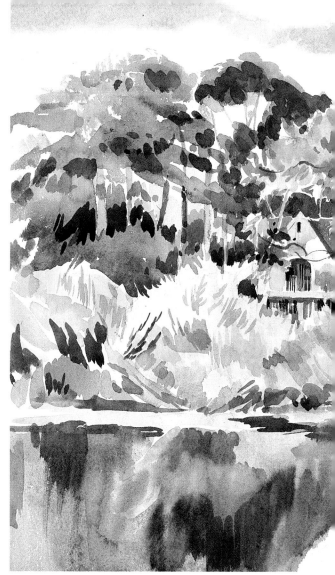

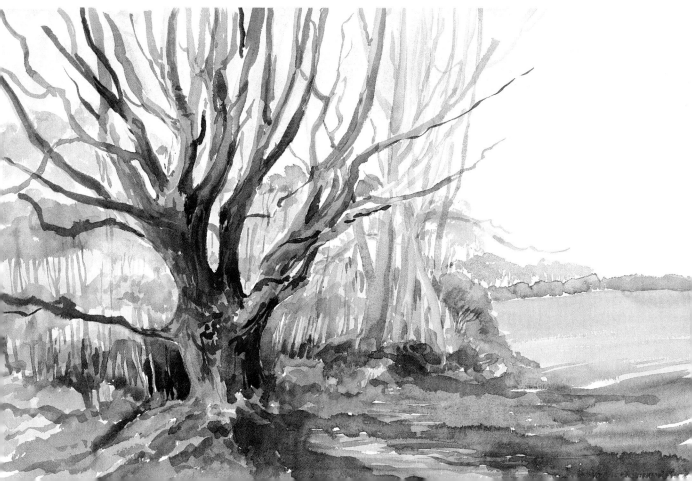

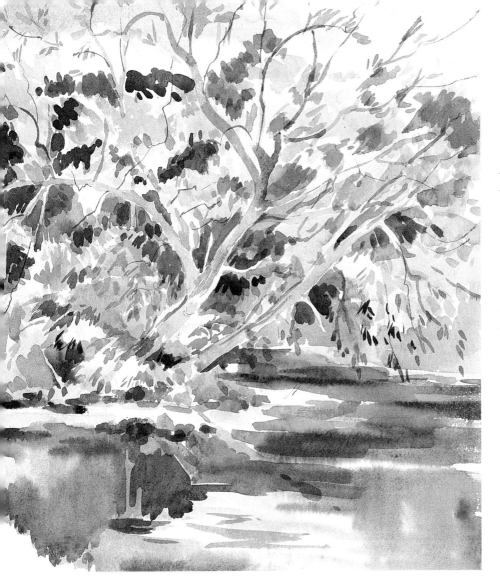

An Old Boathouse
An example of painting different trees and bushes, the reflections showing the different treatment necessary for water and foliage. Dense foliage is a problem, and a time when you need to be quite positive about colours and shapes. Some artists deliberately change the local colour to make it easier, and doing this – painting in greys, for example – can in fact be very rewarding.

◁ **An Oak Tree**
This is a winter painting on quite a cold day, and it was the sunlight on the branches that caught my eye, turning them into a vivid green. This tree was on the edge of a copse in the midst of brambles, scrub and low vegetation, which I left out. I found the spaces between the branches interesting, and wished I could have been further away when I could have portrayed the whole tree.

▷ **A Scots Pine**
Often when I go out to paint I am not so much concerned with painting 'a picture', but with painting a particular aspect of a subject that interests me. Occasionally you might return to a certain spot that you remember as being suitable, only to find it quite different for some reason. This was so in this painting of a Scots pine, although it became a good example of light, medium and dark greens. It was painted directly with a brush, without any pencil drawing, mainly because of lack of time.

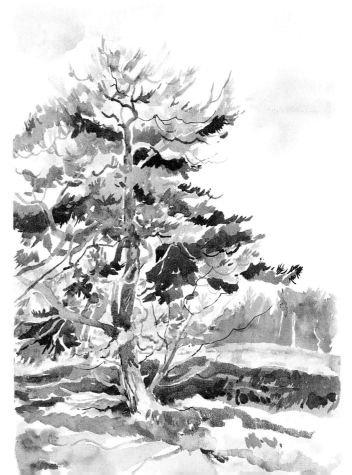

Drawing and Painting Buildings

We rarely see gardens and parks without reference to buildings of some kind or another. Country scenes often include farms and barns, and some of the most interesting aspects are those which contain some habitation. I usually find that my drawing must be accurate, because if my perspective is incorrect nothing seems right, and at a later stage corrections become quite difficult.

I have a strategy which works for me when drawing anything that has some perspective in it. I trust my eye as far as possible, then check my perspective by establishing my eye level and vanishing points. I check any angles by means of an open penknife, and look hard at all the shapes to decide if they are long, narrow, fat, wide, diamond or trapezoid. This requires a great deal of concentration, and often going away from your drawing and then returning will alert you to errors. Keeping verticals vertical is essential, so a drawing board and a long pencil or plumb-line are helpful. A ruler can establish directional lines, as can small sketches. Such pencil drawings should act as an aid to painting – too much slavish following of a pencil drawing can make a painting stilted. There can be a happy balance between a painting which looks right and yet is out of drawing. However, onlookers are rarely able to check the drawing, and are always ready to appreciate charm.

Grassington, Yorkshire
When I started this painting I was captivated by the gardens, but somehow the pattern of the roofs took over. There is quite a high eye level in this painting, with houses on different levels and at various angles. The distant hills were covered in mist. When you are at a place painting quietly on site, the whole atmosphere of the area floats up to you and you become quite familiar with the scene and its inhabitants; this is quite unlike the feeling and memories that photographs evoke.

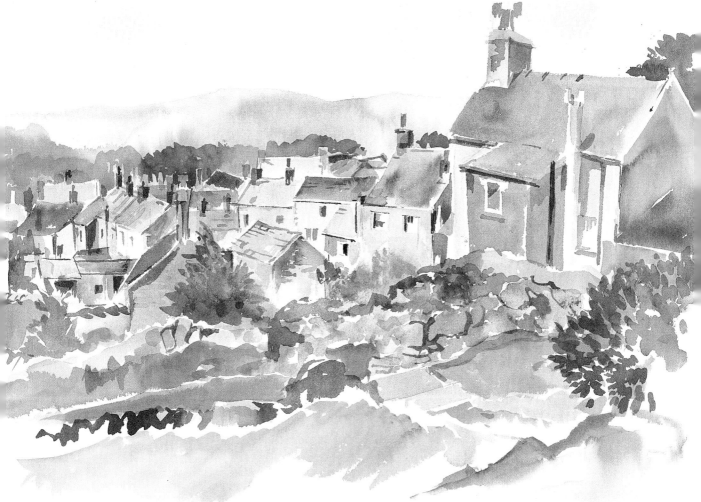

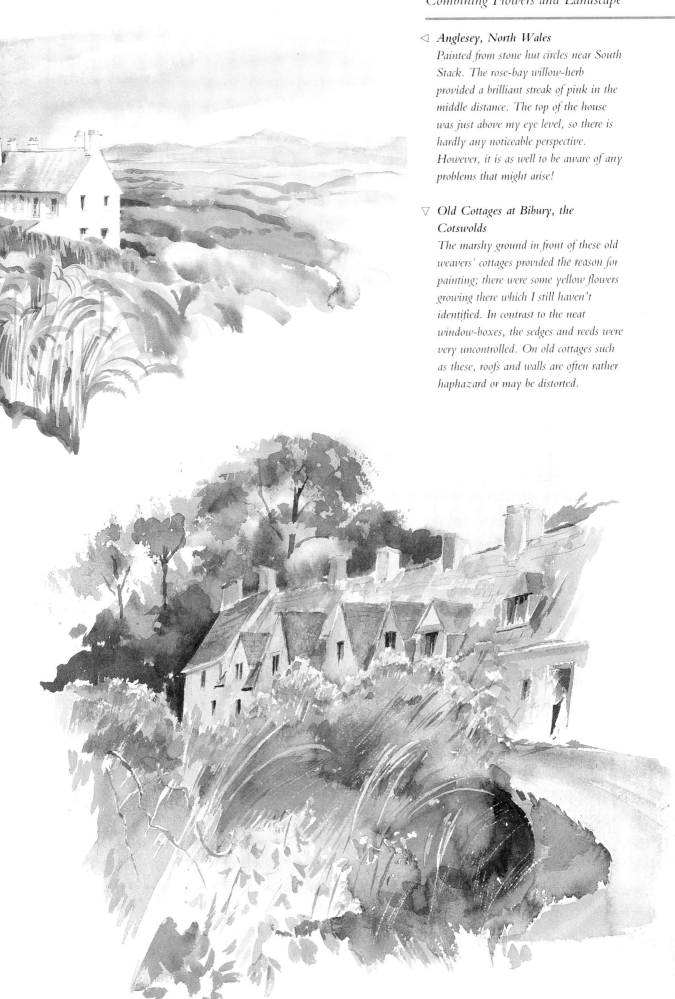

◁ *Anglesey, North Wales*
Painted from stone hut circles near South Stack. The rose-bay willow-herb provided a brilliant streak of pink in the middle distance. The top of the house was just above my eye level, so there is hardly any noticeable perspective. However, it is as well to be aware of any problems that might arise!

▽ *Old Cottages at Bibury, the Cotswolds*
The marshy ground in front of these old weavers' cottages provided the reason for painting; there were some yellow flowers growing there which I still haven't identified. In contrast to the neat window-boxes, the sedges and reeds were very uncontrolled. On old cottages such as these, roofs and walls are often rather haphazard or may be distorted.

Painting in the Summer

For artists everywhere, summer is the time to get out to paint flowers and landscape. The weather is agreeable, you feel comfortable, and paintings should roll off the easel; in fact there are often too many subjects, particularly if you have a garden, when there are many choices. Painting landscape can often depend on where you live or take your holidays. I have a certain idea of where I like to go in summer, and also prefer to have some preconceived ideas as to subjects; when confronted by new surroundings I find that panic can set in, as it is often very difficult to decide exactly how to tackle unfamiliar scenes.

With regard to the wealth of subjects available in summer, it is often a good idea to have some sort of theme that you can set yourself, and to work within that range. You could settle for garden paintings, or plants in pots, or paintings where the main idea is water, or flower shops and markets. There are many suggestions to be made. Set yourself achievable targets If you are a beginner, plan to learn to paint one thing well, and then to enlarge your scope to take in another feature. If you have trouble with perspective, try and resolve it. If you can't draw ellipses, practise them. Often, what seems to be a particularly uninteresting subject can turn out to be a fascinating interplay of shapes and colour.

One flower that has always intrigued me is the poppy: there are many different varieties and they are all interesting – not only the flowers, but the leaves, buds and seedpods are lovely to try and portray. The latest one to captivate me is the Himalayan blue poppy, *Meconopsis*, a number of which I saw growing in the Savill Gardens at Windsor, so strikingly blue that I will never forget them. Unfortunately the weather was poor so my references were photographs, but what a perfect example of flowers in the landscape!

Himalayan Blue Poppy Meconopsis

When I first saw the distinctive, graceful Himalayan blue poppy, I was very taken by its 'blueness'; and when I saw them in a mass for the first time I was amazed by their colour and beauty. Set against the beautiful trees of the Savill Gardens they seemed out of this world, unreal, perhaps more so because the weather was so damp and there was absolutely no sunlight. So, how to paint them? The only answer was to use photographs – yet in spite of two visits on consecutive days, it just rained more and more! The painting opposite was my second attempt, as it was hard to feel I had captured anything like the beauty and colour in my first effort. One advantage of working at home is that you can experiment with washes in a way that you cannot on location. I had managed to take two photographs – one close-up, the other further away – so I composed my painting between the two (having already done one painting, I was better prepared for the second).

As this was painted in the studio, I was more able to control my wet-in-wet washes. In fact I damped the paper and then placed the poppies only approximately with cobalt, after this using Naples yellow, which combined with the blue to achieve a soft effect. As the painting was drying, I used ultramarine to define the flowers further. After drying, the background leaves and trees were used to contain the flowers, and more washes were laid to indicate sky and so on. There is very little detail, only the stamens and stems.

Oriental Poppies

When the oriental poppies first came out I was entranced, particularly as during the previous rather wet summer the buds had just dropped off before blooming. I found the colour difficult, and was too impatient – I couldn't wait until there were more flowers more fully opened, hence this first attempt (left).

The painting overleaf was a second attempt a week later and, I feel, was more successful; both were painted on Saunders Waterford 140lb Not, approximately 15 × 22in (38 × 56cm). The poppy painting overleaf was painted in a similar way to the blue poppy (opposite), that is, loose fluid washes on damp paper followed by the detail of leaves, stems and buds. Some of the flowers have both hard and soft edges.

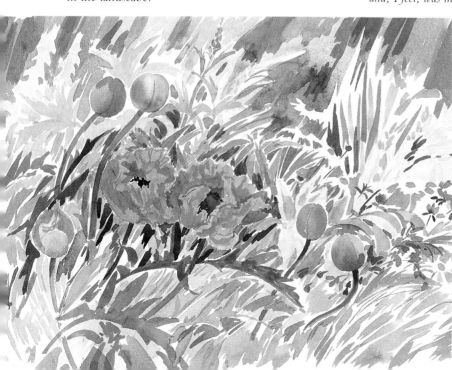

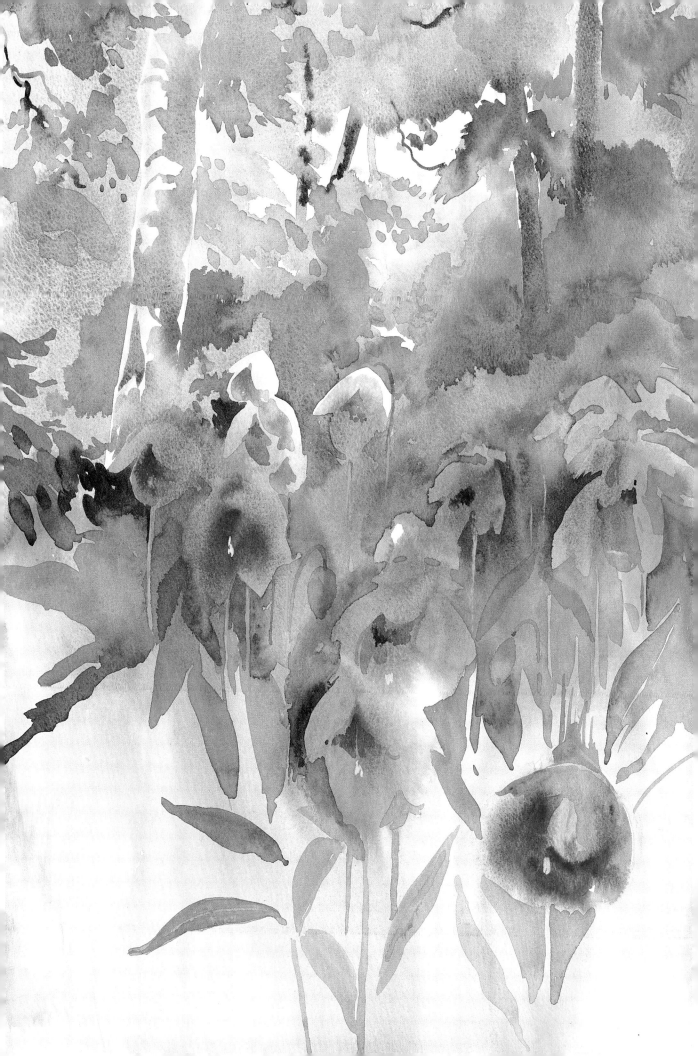

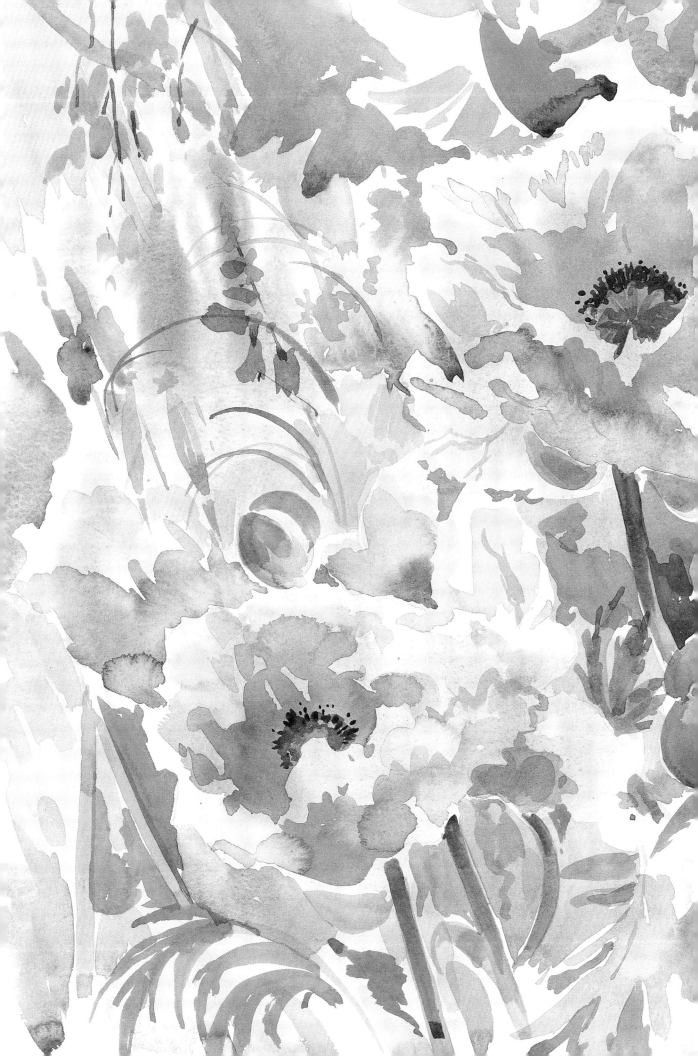

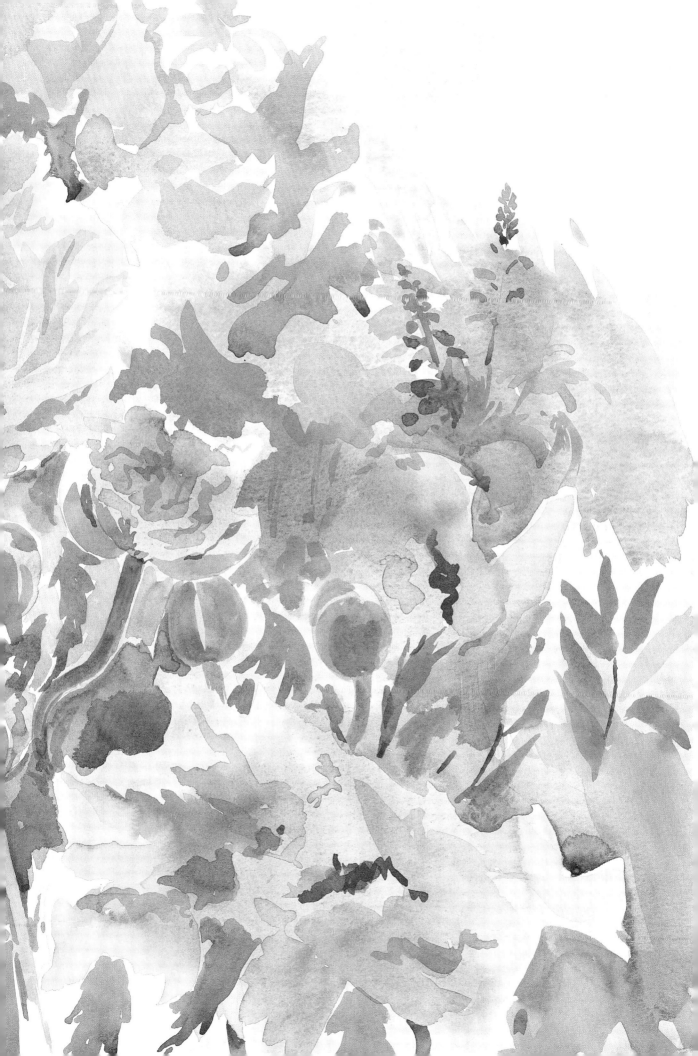

Painting in the Winter

Different times of year call for different painting approaches; not so much for different methods, but in the way you plan your working day. Subjects, although just as numerous, are often not so accessible. You have variable light and weather conditions to contend with, and the weather can influence your painting in various ways quite apart from its psychological effect. Sunshine in winter can be magical, and a certain late afternoon light, mist and clouds can be inspirational – but these have to be weighed against damp surroundings and cold feet! In the part of the country where I live the idea of painting outside in winter almost calls for a medical certificate! So you must have adequate clothing and footwear, a great deal of stamina, and you must be able to choose your painting time to suit yourself or you will find yourself painting in miserable conditions.

However, if you have provided yourself with enough reference – sketches, ideas, photographs – there is no reason why the colder months should not be fully occupied. And besides this, there are the many still-life subjects that you can think up yourself to paint in your studio/kitchen/bedroom. Glasshouses are sometimes a possibility, although this will mean having to approach your local college of agriculture, or garden centre, and ask permission.

The arrival of snow always makes me rush for my paints. There is something calligraphic in the starkness of trees against the whiteness of snow; though again, it can be a very chilly experience – but good practice for working directly with the brush. Colour can often be seen more clearly when it is surrounded by white snow; together with birds feeding in the wintry conditions and children playing, what more can we ask for in the way of superb subjects?

Flowers in Winter

Painting in winter can be frustrating. It is generally too cold to go outside, the light is bad, and it gets dark early. So what to do? I find that to stretch some paper so that it is waiting and ready for the right moment is a useful excuse to get me painting. Odd winter sunshine is most helpful, as it illuminates and inspires; I am fortunate in having a sunny porch where certain pot plants live happily in the coolish situation, and these provided me with the subject illustrated here. The daffodils were bought, the catkins found, and the primula and Christmas cactus seemed to be made for each other. This was a large painting and, as time was short, the only drawing was with a brush. The garden outside the window provided the dark shapes which

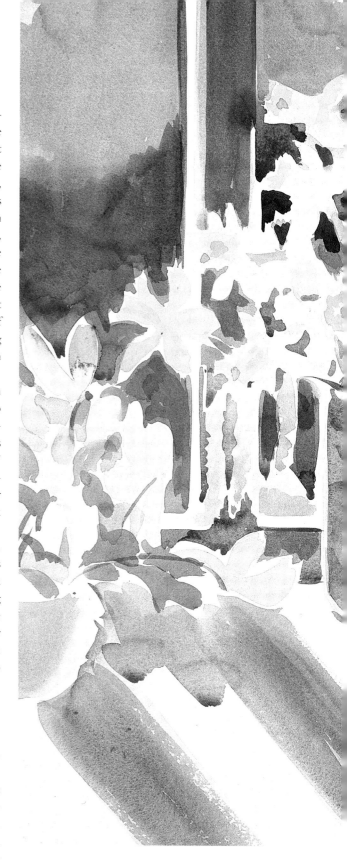

contrasted with the pale daffodils.

It is quite a difficult exercise, and requires concentration, to get things in the right places, and not to lose sight of the original idea of bright winter sunshine (especially when the sun is in one minute and out the next). This was almost completely painted with a No 12 sable, and was

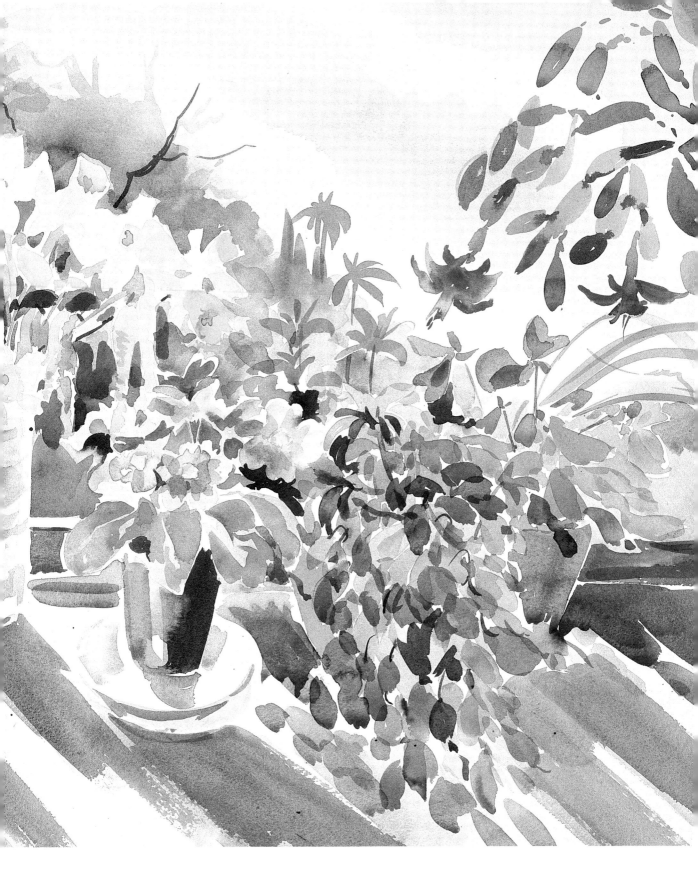

useful brush practice for shapes of leaves and suchlike. The sun disappeared completely in the latter part of my painting time so establishing shadows was an early part of the painting procedure. The paper was Saunders Waterford 140lb Not, and the time taken approximately three hours.

Daffodils in the Porch
Bright daffodils and dark shadows are an irresistible combination, but one that needs an immediate approach. It is helpful, when time is short, to compose a painting in your 'mind's eye' on the paper before using a brush.

Building up Confidence

Confidence in painting comes from practice and experience. All artists suffer from periods of inactivity and can lack confidence at any time, just like anyone, but the kind I mean is built up on past work, so that you don't have to hesitate when starting a new subject or painting something you have never tackled before; so that you know how you are going to start, what paper and what colour you are going to use, and just what your approach can be.

Finding suitable subjects can be a problem – though having said that, much of the time ideas for painting present themselves fairly easily. Thus you can be on holiday and see many things you would like to paint; or you can suddenly see things around you which you hadn't noticed before; or you can be inspired by ideas given to you by a tutor or by looking at other paintings. Sometimes, however, there are so many ideas that you can be overwhelmed and it is difficult to decide on anything. On a visit to the Royal Botanical Gardens at Kew recently, I felt very much as a beginner would and spent most of my time just looking!

If you can, decide upon your subjects in advance and notice the time of day, the sunshine and shadows; for instance, sunshine on white paper can be blinding, and occasionally you can get very hot indeed. Sunlight can be elusive, but light may well transform a mediocre subject; it will illuminate and inform. Moreover the shadows that sunlight casts have the capacity to provide drama and compositional direction, and give vivid contrast to your painting.

Sometimes subjects can be very fleeting. Apple blossom can look beautiful for several days, and then just when it seems you have the time to paint it, rain and strong winds come along and the blossom blows away, and you have to wait until the following year!

At other times it is a better option to work from sketches or photographs, or you may have gathered ideas from other sources: galleries, the television, newspapers and books. In public places it is not always possible to paint comfortably or achieve a great deal, especially if the weather is poor. If this is the case, the camera is the answer, maybe backed up by sketches or colour notes to provide the details you will need to be able to paint. This kind of information can never really be as good as the real thing; nevertheless it may sometimes act as a stimulus for more creative work.

It can be helpful to study the work of other artists to appreciate just how much thought and planning goes into producing any painting. As an artist you do not produce on a conveyor belt and each new venture can seem like the first – confidence can come slowly at times.

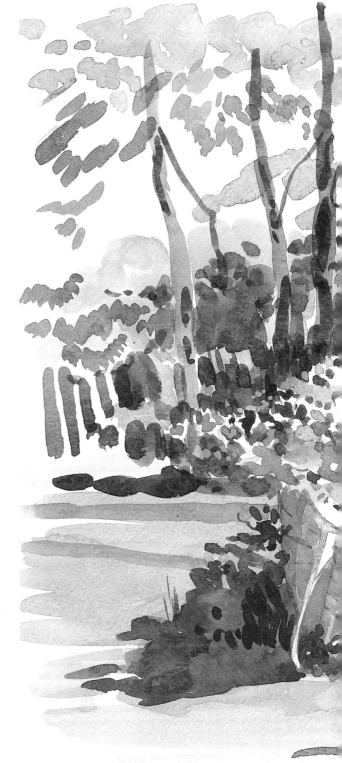

Tulips

Often it is one particular aspect of a subject that appeals – it could be the light, the colour or the arrangement. In this case it was the oddness of the flowers being in a boat that in the first instance took my eye, and then the light striking the tulips. I drew in pencil first to get the shape of the boat, and then started to paint, using cobalt for the forget-me-nots and rose madder for the tulips. Body colour was useful to help the feeling of a drift of forget-me-nots. Apart from that, I used my usual palette.

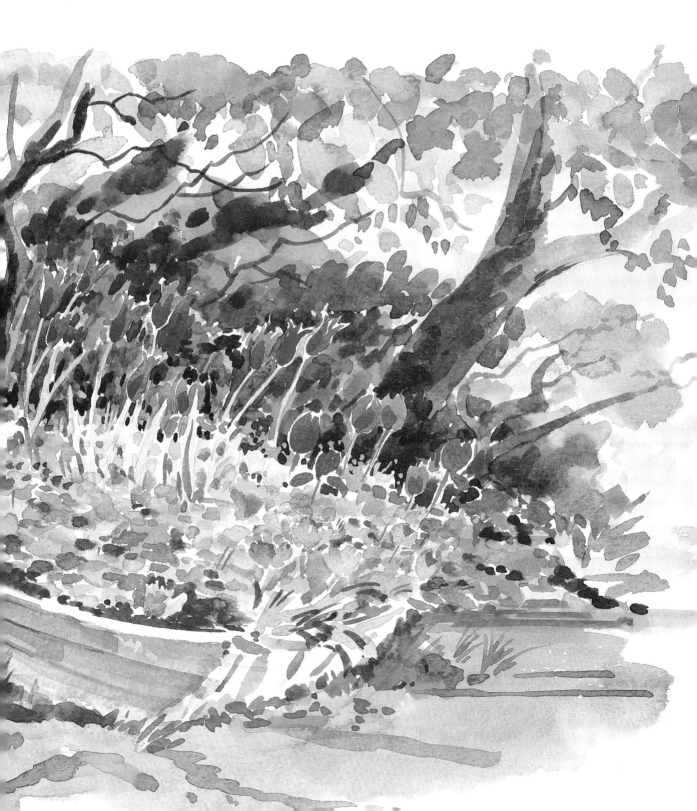

DEMONSTRATION

Poppies

The camera is a very useful aide; it provides quick reference and can act as a starting point, or as an idea for a painting. The poppies illustrated here were seen on the side of a motorway slip-road where the banking had recently been constructed; poppy seeds can lie dormant in the soil for a long time, and when the earth is raked they appear in the summer as if by chance. A hastily taken photograph provided the impetus for the painting. Several ideas were tried out, and a small rough was made before stretching the paper and starting. I love painting poppies of all types; the petals are an invitation to the watercolourist, the shapes are usually simple, and the colour straightforward. On this occasion a decision had to be made regarding the method of painting that I was going to employ, and because I like painting fairly large, I opted for a free wet-in-wet approach. If you have never painted this way, it could be rather daunting; on the other hand, it is fun! You will learn about colour and colour mixing, you will have to work fairly fast, and must not be upset if your painting doesn't work too well. Look upon your painting as an exciting venture, and you will enjoy it. You can practise this approach with different sorts of flowers and landscape again and again, until you have confidence.

MATERIALS
Use 140lb Saunders Waterford Not paper, stretched, 15 × 22in (38 × 56cm); a large wash brush and Nos 8 and 4 sable brushes; a sponge; the usual palette plus bright red and indigo.

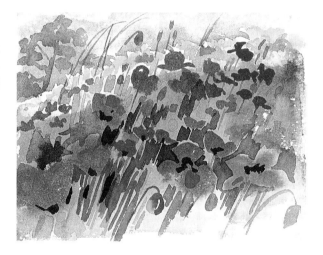

Stage 1
On dampened paper, using the large brush, float in a summer sky on the top third of the paper. Then wash in a pale pink wash where the main flowers will be. Drop in yellow ochre in approximate areas of foliage, but don't worry if it runs and merges; this will form the background to the painting. Allow it all to dry.

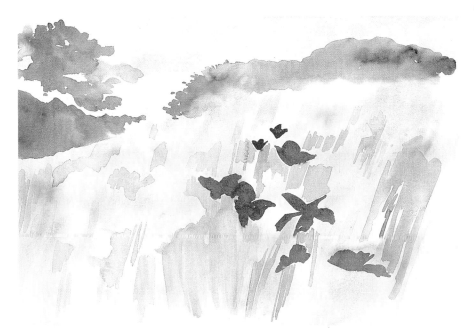

Stage 2
On the now dry paper start painting your poppies, using your references for shape and so on. You can also start painting the lightest green, using strokes which will resemble stalks, grasses and leaves. The background of trees and bushes can be painted now, using a blue-green (prussian, plus a little yellow) and indigo to suggest distance. A Naples yellow was also used in the distance while the paint was wet.

Stage 3
A medium green can now be used for stalks and buds and further foliage. The greens used were prussian blue, yellow ochre and cadmium yellow pale for the lightest green; prussian blue, cadmium yellow pale plus a touch of burnt sienna for the middle green; and prussian blue and burnt sienna for the very darkest touches. These greens are full of pigment, and not watery! More red can be used on the poppies to define the petals. This part of the painting needs a fair bit of concentration, as you are defining stalks and leaves but trying to keep the look rather free. Use the No 4 brush for the fine stems. If your hand is wobbly, try a few stems on rough paper first. Your centre of interest is about one third up the paper, so that areas around this need not be so defined. A feeling of poppies in the wind should be in the back of your mind!

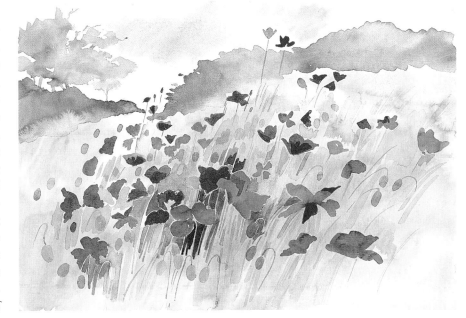

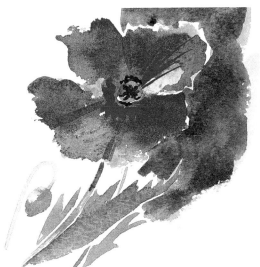

(Overleaf) Stage 4
The darkest greens are now painted, and further definition on the poppies, including the dark purple-blue centres. Small white flowers are painted, using white gouache. Further poppies and stalks can be added as needed.

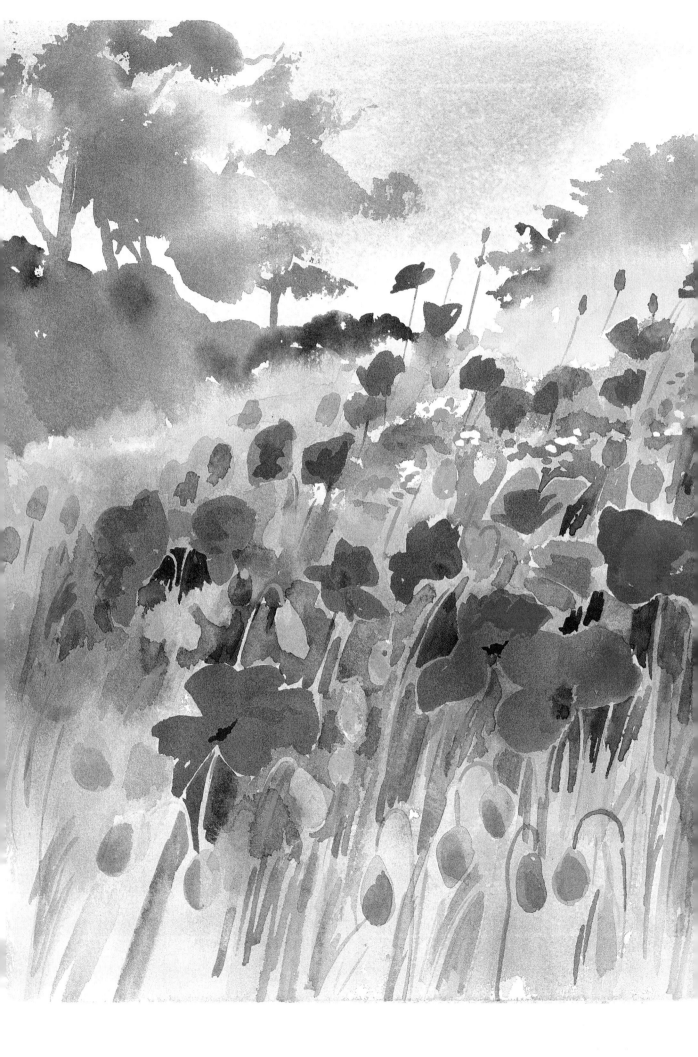

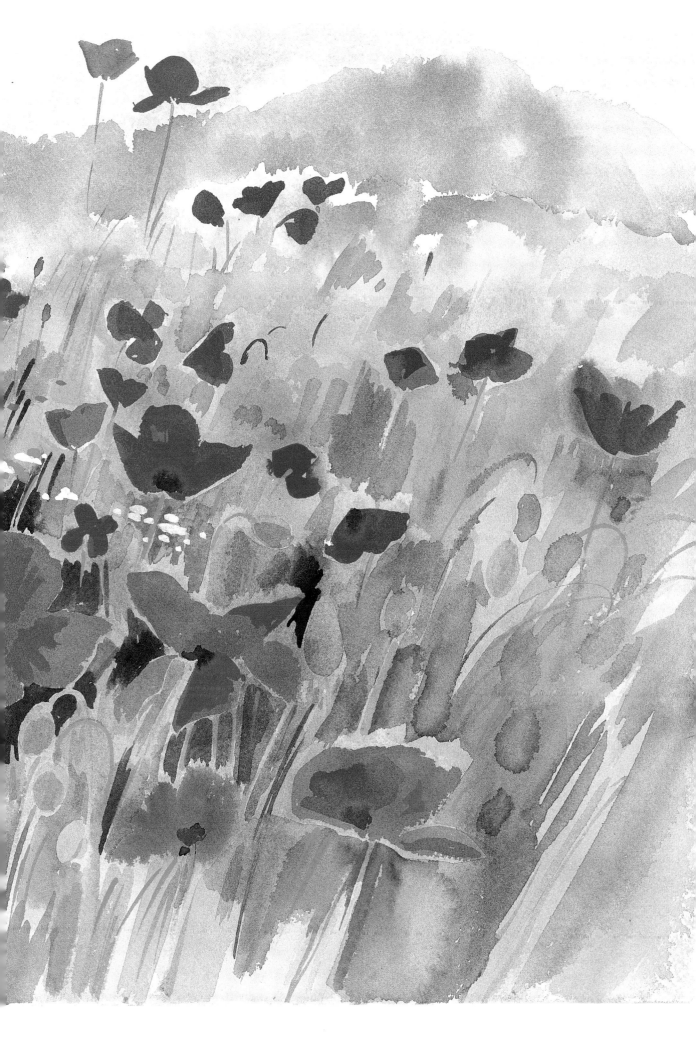

DEMONSTRATION

Disused Kiln, Cornwall

This kiln was situated on an old wharf-side on an estuary in Cornwall. It was a useful place to sit when it rained – the whole of the immediate area was enchanting for the artist, and it seemed that whichever way you looked, a suitable subject would appear. The blue hydrangeas against the dark hollow provided a good subject.

MATERIALS
The paper is Fontenay Rough, 14¼ × 18⅞in (36 × 48cm); brushes are sable Nos 12, 8 and 6; and the paint: brown madder, ultramarine, cobalt, yellow ochre, cadmium yellow pale, prussian blue and indigo.

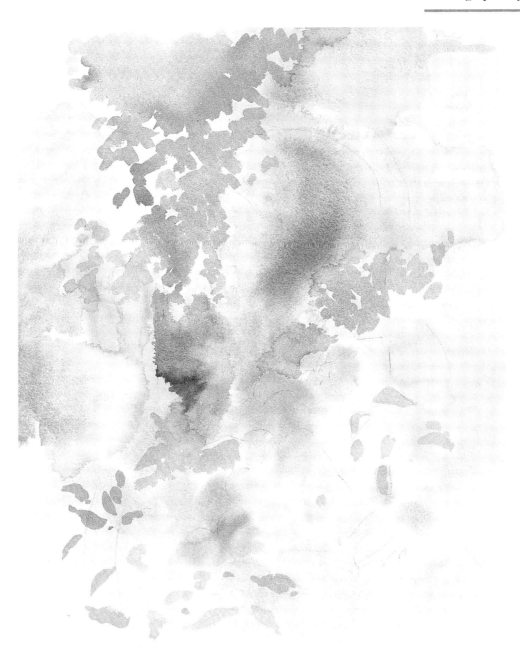

◁ *Stage 1*

Start by drawing the main features lightly with a pencil, that is, the arch, and the placing of the flowers. Prepare the colour before damping the paper: brown madder, yellow ochre, cadmium yellow pale, ultramarine and cobalt. Having damped the paper, use brown madder with a light wash, just lightly brushing in the colour, then pick up the yellow ochre and do the same: this will be the base for the arch and stonework. Next, paint the hydrangeas with a pale wash of cobalt. The green consists of yellow plus ultramarine, and is put on in the same way.

△ *Stage 2*

Mix ultramarine and brown madder to make a light grey, and paint another light wash as indicated. Allow the painting to dry. Using ultramarine and cadmium yellow, mix a medium green and paint in the foliage, trying to leave some of the light green on the overhanging ivy. Indicate the light area of the arch by dropping in brown madder and green and darker grey. Again, if the colour runs, don't be too concerned at this stage; we are not aiming for exact realism, but an approximation of the scene.

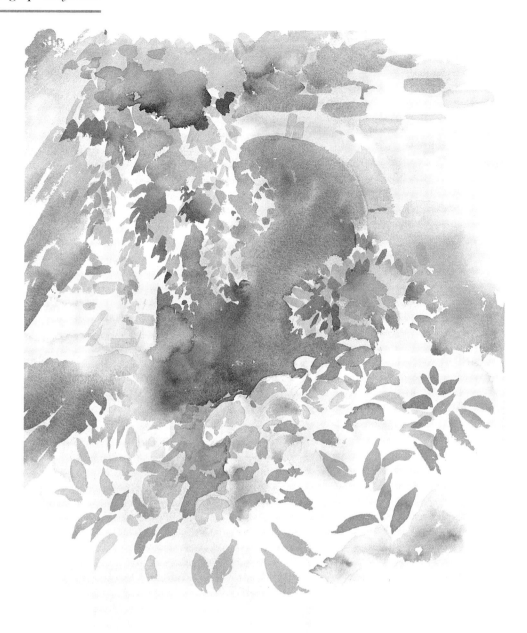

△ *Stage 3*
Using a darker green – ultramarine, plus cadmium yellow pale, plus prussian blue – paint in the darker foliage; also increase the cobalt to paint the hydrangeas a little more. Mix ultramarine and brown madder to make a darker grey, and use this to fill the kiln niche and to paint brick and stone shapes, and also shadows.

▷ *Stage 4*
The final painting is the one that pulls the whole work together, when the darkest tones are applied and also the detail, for example on the flowers and various small branches. A little body colour – gouache white and green – was used to highlight the lightest leaves. If you find it difficult to achieve your darkest tone, use more pigment!

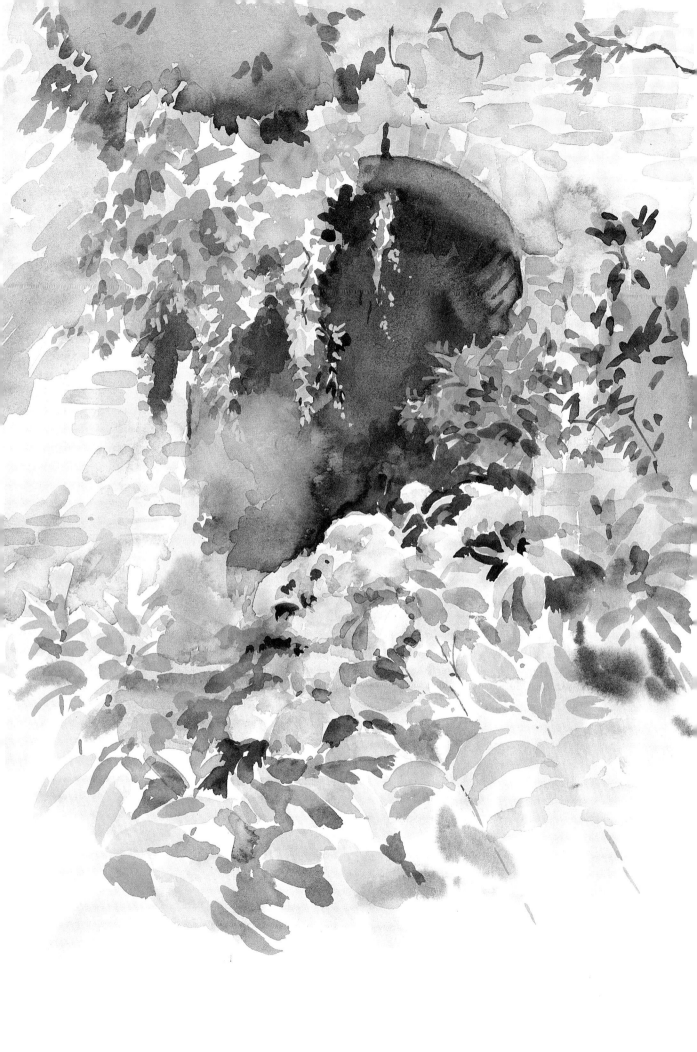

Painting Vegetables and Fruit

We often overlook subjects which are right under our noses. We prepare and eat fruit and vegetables every day, yet mostly we ignore their colour, shape and beauty. Those of us who are lucky enough to possess a garden, and take the trouble to grow vegetables and fruit, are perhaps more aware of their delights. Cabbages are like roses, broccoli has subtle charms, and exotic vegetables like aubergines and peppers can provide material for the artist. The simple shapes of some vegetables are good for nervous beginners, and most artists delight in painting apples. The greengrocer always has a tempting display that I can buy, take home and paint, and then eat! Strawberries, cherries and melons are favourites, for more than artistic reasons. Grapes growing on the vine, and apples on trees are nearly always intriguing subjects.

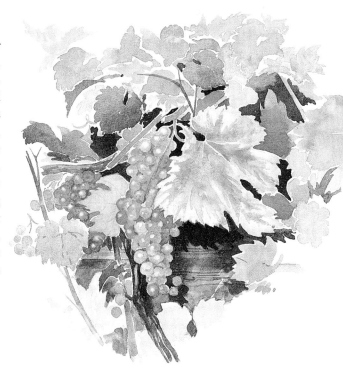

▷ *Grapes*
This is a straightforward study with no attempt to add or change anything. Decisions had to be made regarding the highlights on the grapes; the stems also grew haphazardly and some care was needed to ensure they looked correct.

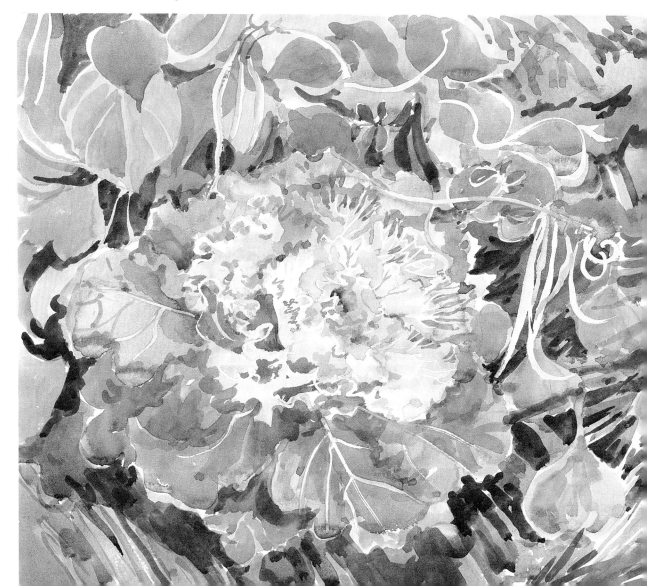

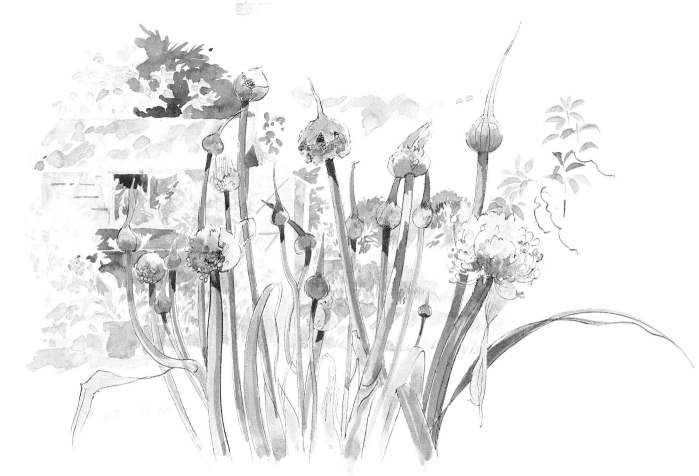

Leeks

Onion flower-heads of all types add interest to the garden, and when dried are very decorative in winter. In this illustration they are shown as they grow in my garden. The detail seemed to suggest ink, and the flower-heads were drawn in first. The background of the garden shed was loosely painted in Payne's grey, and quite pale washes were used on the leeks themselves. The plants were too tall to portray the whole plant. Indian ink with a steel nib was used, on Fabriano Artistico, and the washes were in watercolour.

Cabbage, Onions and Beans

This is a more generalized, close-up view of the vegetable garden. The decorative and delicately coloured cabbage took my eye, and I tackled it as a deliberate exercise using masking fluid; though as the painting progressed it was obvious that the beans and onions needed to be put in, too!

I used a Bockingford tinted paper, and first of all drew the frilly, light parts of the cabbage with masking fluid and a brush. A light, medium and dark green were used for the other parts, which were painted next. Last of all the masking fluid was rubbed off with my finger, though some of the light lines had to be slightly darkened with a wash. I sat directly above the cabbage and painted it life-size.

DEMONSTRATION

A Basket of Onions

The subject was painted outside and placed on the grass, and it was decided to leave the background plain. The onions were left as they tumbled out of the basket.

The arrangement was very lightly placed on the paper in pencil – and there are, of course, all sorts of ways of starting! I will list a few approaches to the drawings:

a) Make a small thumbnail sketch 3 × 4in (7.6 × 10cm) to place the subject on the paper.

b) Enlarge this by selecting a centre point and working outwards, or by making the shape of the whole area; this can be quite lightly drawn, using dots and lines. You can then plot the individual shapes and areas. This type of initial drawing can be used on any type of composition, whether the subject is landscape, flowers or still life.

c) If you are confident enough, you can use your brush instead of a pencil and in this way will be nearer to painting. It is really a matter of judging distances and spaces, and if your initial painting (or drawing) is light enough you can correct mistakes fairly easily.

MATERIALS

The palette used was prussian blue, ultramarine, brown madder, yellow ochre, raw umber, burnt umber, burnt sienna, cadmium yellow pale; brushes were No 8 sable and No 6 synthetic; the study was painted on Whatman paper, Not 140lb 13½ × 19½in (34 × 49cm).

Stage 1

A wash of yellow ochre was brushed over the whole area, but trying to take note of any highlights on the onions; these were very pale and were left as white paper. While the wash was wet, a little burnt sienna was dropped in.

△ *Stage 2*

Next, a pale green mix (prussian blue and yellow ochre) was placed approximately where I saw green. (In fact these washes ran and mixed on the paper, some in the right places, some not. Learn not to worry at this stage, and certainly don't try to touch anything up.) As these washes were drying, I added further green to indicate the onion stalks (these were mostly on dry paper, so didn't run). The green was varied from pale to darker, but I wanted to keep an earthy, rather washed-out, dried feel to the painting.

▽ *Stage 3*

Further washes were laid, working up to the darker washes. The sun was fitful, in and out, which changed the darks considerably.

The basket was painted using burnt umber, with the shadow in a darker shade. The dark areas were sought out and painted using burnt umber and ultramarine; it is always quite surprising how the addition of the dark areas really pulls a painting together. Sometimes I might place a dark area early on to give some kind of painting scale, and in order to know the tonal range I make a note of the darkest and the lightest areas.

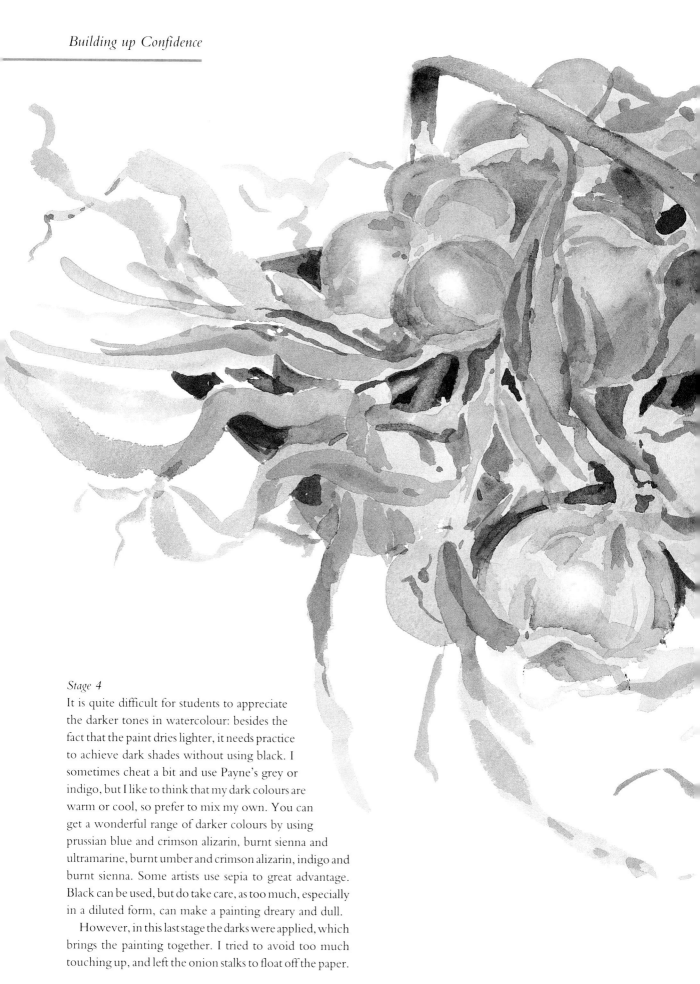

Stage 4

It is quite difficult for students to appreciate
the darker tones in watercolour: besides the
fact that the paint dries lighter, it needs practice
to achieve dark shades without using black. I
sometimes cheat a bit and use Payne's grey or
indigo, but I like to think that my dark colours are
warm or cool, so prefer to mix my own. You can
get a wonderful range of darker colours by using
prussian blue and crimson alizarin, burnt sienna and
ultramarine, burnt umber and crimson alizarin, indigo and
burnt sienna. Some artists use sepia to great advantage.
Black can be used, but do take care, as too much, especially
in a diluted form, can make a painting dreary and dull.

However, in this last stage the darks were applied, which
brings the painting together. I tried to avoid too much
touching up, and left the onion stalks to float off the paper.

Painting People

Why are there so few people in my paintings? Mainly because I am not fast enough to capture in watercolour the moving figure, and can't make up my mind whether to put in blob people or not! If I have my sketch-book immediately to hand I can jot down a figure and then paint it more at my leisure, but I still don't find it easy. Also, the small size of figures in a landscape is somewhat inhibiting. Figures do add interest to a painting, particularly when depicting street and beach scenes, but apart from gardeners my landscapes are normally uninhabited.

Interesting subjects which do need figures are garden shows, flower shows and parks. Make sketches to improve your figure drawing, and then transcribe these into watercolour, using as few strokes as possible to keep your painting as fresh as possible.

Gardeners
Having these two gardeners in a sketch is useful, as they could be used later on in a garden painting. It was really the attitude that I wanted to capture, but the counterchange – light to dark and vice versa – also seemed important.

The best way to master the technique of putting figures or animals in a painting is, of course, to keep on painting them! Don't try to put in every detail, but keep to the bare essentials; try to capture character and movement. If you need to improve on figure work, it might help to go to a costume or life class.

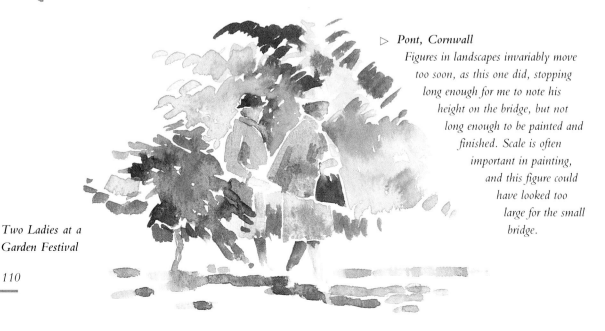

▷ *Pont, Cornwall*
Figures in landscapes invariably move too soon, as this one did, stopping long enough for me to note his height on the bridge, but not long enough to be painted and finished. Scale is often important in painting, and this figure could have looked too large for the small bridge.

Two Ladies at a Garden Festival

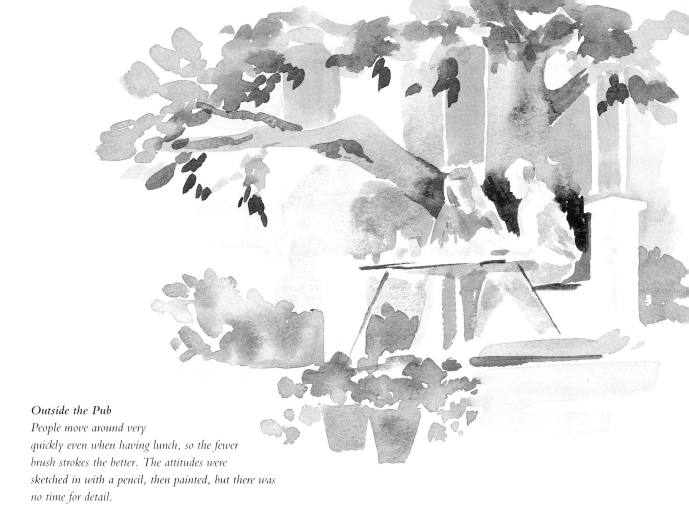

Outside the Pub
People move around very
quickly even when having lunch, so the fewer
brush strokes the better. The attitudes were
sketched in with a pencil, then painted, but there was
no time for detail.

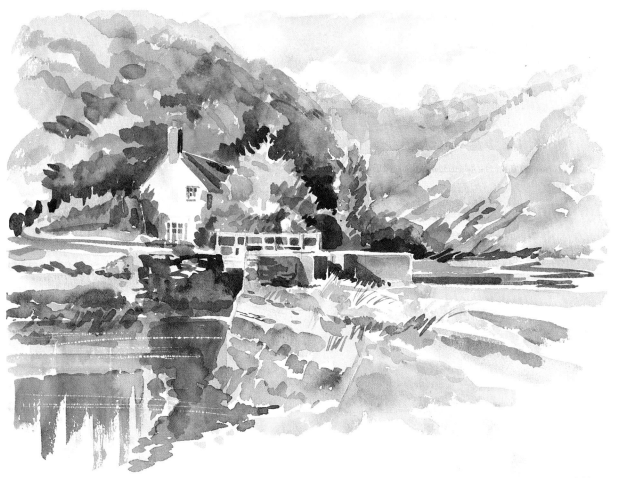

Painting Gardens

Occasionally you see certain subjects which make you reach for your paint-box, and while they might be rather 'picturesque' they can stretch your painting ability. Painting gardens which contain groups of flowers is a task many students find difficult, the flowers often ending up as spots of colour and looking odd. Our eyes can take in an enormous amount of detail, but when painting, this detail has to be simplified in order to convey the impression of mass, just as you would if painting a group of trees or creating a feeling of distance by blurring and softening colour. Groups of plants can be indicated by colour, and brush strokes can be used to vary direction and shape. Flowers often appear as dots, that is, small light shapes on a dark ground. Watercolour washes can often be overpainted in gouache or body colour to achieve a certain amount of necessary detail.

Hampton Court in Spring

The garden at Hampton Court Palace can definitely be described as one of the larger varieties! In spring, the daffodils are worth a special visit: some painting subjects just seem to present themselves all on their own, and daffodils are ready-made! En masse, however, they are really a blur of yellow, on a dull day contrasting with dark foliage, and in sunshine appearing even brighter against the dark green evergreens. So here is a chance to try out your different yellows: aureolin, gamboge, cadmium. The small sketch opposite was painted on a very overcast and

The Bird Table
This corner of the garden was painted in the spring, and I tried to convey a feeling of the brilliance of the kerria which appeared as lots of yellow spots. Perhaps garden painting such as this needs more distance to avoid spottedness.

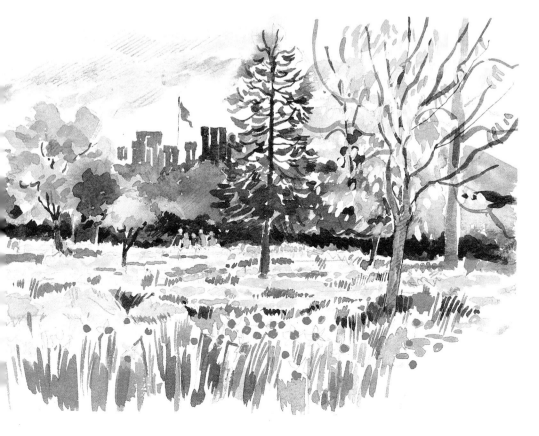

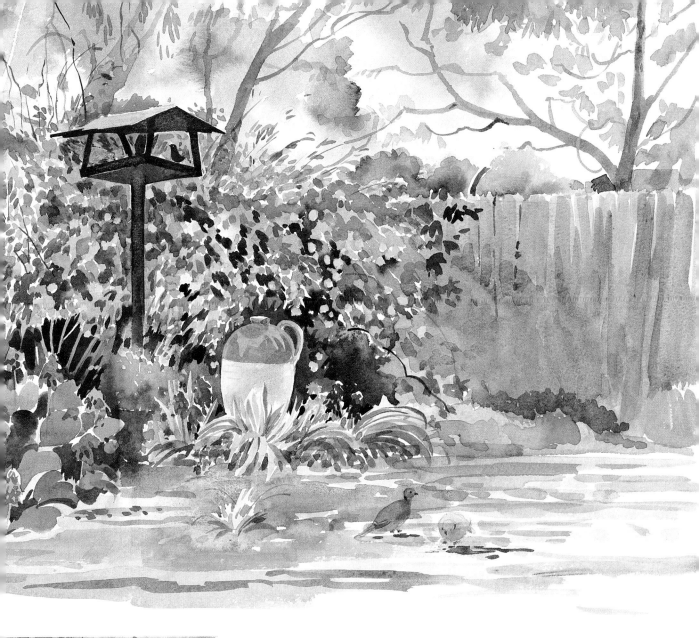

chilly day (not conducive to painting) at the end of March; some trees were in early leaf, others still had bare branches. The effect of the massed daffodils was entrancing, but there was the problem of how to make them recede, and how to overcome any problems of scale; they were therefore made smaller as they went away into the distance, and the closer ones were painted in sharper focus. The figures in the distance give some idea of scale.

Detail in painting is mostly a matter of personal preference and your own individual style. Some artists develop a liking for absolute realism, whereas others are happier with a looser, more free approach. Style is something which develops with time and experience, and comes with good draughtsmanship.

The two small paintings of daffodils at Hampton Court are attempts to portray the kind of scene which evokes much praise for its beauty, but when down on paper does not look so impressive. Photographs taken at the same time did not convey the scene at all well!

Daffodils at Hampton Court

Pattern

Pattern-making is something we do as children at school, to create order out of chaos. As adults we often make patterns unconsciously, but as artists we should make use of pattern-making to create order and harmony in a painting. On the whole, pattern-making is the repetition of shapes; sometimes this happens by accident, and as such is seen frequently in flowers and leaves, but we should realize it in subtle ways. Pattern often occurs unintentionally in brush strokes and repeating line work; illustrators, however, use line as well as form and colour intentionally to exploit pattern and create texture and interesting surfaces.

Overlapping ivy leaves create their own patterning; daisy-type flowers are good examples of pattern occurring in created form, something that we as artists can exploit and use to good advantage. The urge to make patterns is very strong, and while it is good to have a free approach, there are all sorts of ways in which to approach painting.

Pattern-making can be both formal and informal, and it is quite natural for us as artists to try to put some sort of order into what can be seen as chaos; many artists do, in fact, put examples of pattern in their paintings to enhance, or contrast with, the subjects. I am speaking here of added pattern, that is, the designs which appear on fabrics or plates or suchlike, the colour of which could contrast with existing colours, or formal shapes contrast with natural shapes. When painting landscapes or flowers it is not possible to do this, and it is the artist alone who has to devise a kind of order.

Sometimes people discover that they have a natural aptitude for pattern-making, and indeed find that they get a particular pleasure from this sort of work.

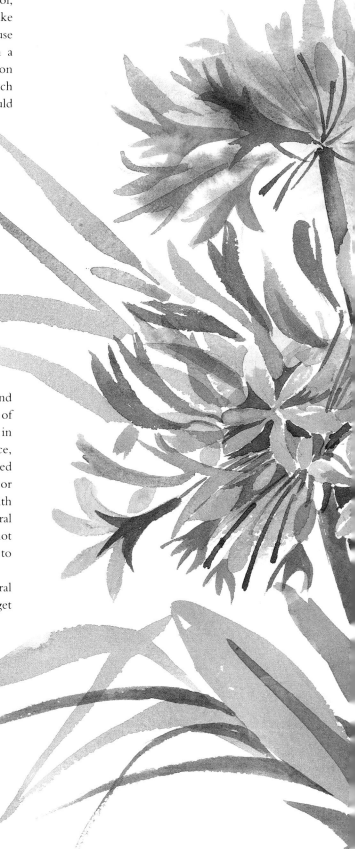

Blue Agapanthus
An example of pattern-making is illustrated to some extent by this painting of blue agapanthus, where both the flower-heads and the leaves form repeating shapes. This sort of patterning can be used quite formally if necessary; a very good example of formal patterning can be seen in the decorative fabric designs of William Morris.

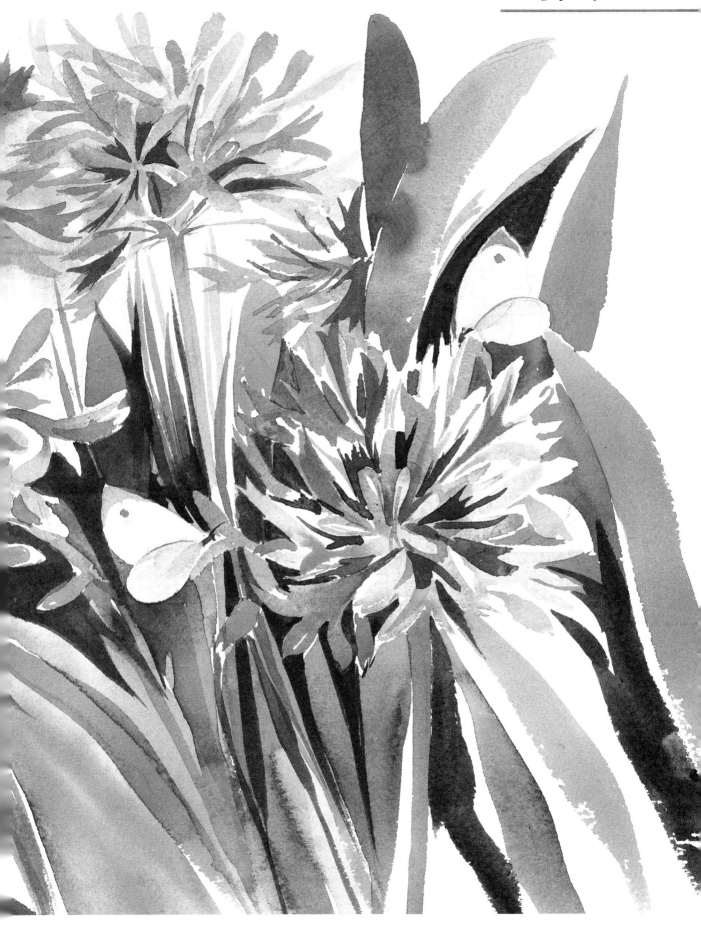

Wild Flowers

Wild flowers are much more abundant than they were, perhaps because we have learnt to treasure and respect them. Also, plants which we tend to regard as a nuisance often provide us with quite exotic blooms; I am thinking in particular of convolvulus and Indian balsam, which are delightful to paint but a gardener's dread. On the other hand, some wild flowers are extremely small and difficult to paint freely. Therefore it is important to be selective, perhaps using small flowers as 'fill-in' material or making use of them in silhouette form to provide a foil for larger shapes. Treating flowers en masse is in some ways easier than painting individual blooms because you have to learn to see colour in blocks, just as you would when painting landscape when you tend to see little actual detail.

As regards wild flowers themselves, ox-eye daisies and poppies make delightful subjects; roses are delicate, and there are foxgloves and buttercups, scabious and bluebells – when in their natural setting these are all marvellous for the artist.

As well as flowers there are numerous fruits and fungi which can make interesting subjects. For example in some autumns, the rose-hips and rowan-berries are vibrant with colour; vines and fruits, apples and plums are also a pleasure to paint, and can provide interesting foreground material. Seashores and rock pools are alive with interest; once you start using your powers of observation there is no end to the possibilities. For instance, from where I sit I can see lime-green hops festooning a birch tree against a sunlit sky – another subject just awaiting attention!

▷ *Convolvulus*

This gouache painting shows how white paint stands out on a painted and grey ground. I started with a very light underpainting of flowers and leaves, increasing the paint thickness as I went along. I found that the tree trunk provided the darks needed to emphasize the white flowers. Gouache dries much lighter, so it is difficult to judge the results sometimes, but unlike watercolour you can overpaint quite freely until you get your desired result.

Painting on a coloured ground in gouache can be fascinating, as there are so many colours you can use for a base. Generally speaking, I would prefer earth and neutral colours, but there is nothing to stop you using your own tinted background of whatever colour you choose. This leads to the idea of other variations, for instance working in pastel on a watercolour background, or using coloured pencils in some way, to achieve the effect you want.

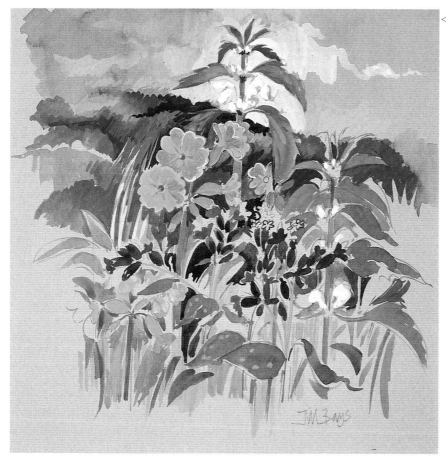

◁ *Cowslips*
This little group of wild flowers, painted in spring, has a simple background and is held together by the sand ground of the paper, which shows through and creates a warmth and unity. Painting on white paper can be daunting, as it is often difficult to decide if you want to cover the white altogether or leave some of it as part of overall design; in using gouache on a coloured ground, the white is added. In this example, quite thin paint was used for the initial brush drawing, followed by thicker paint, and finishing with the lightest colours.

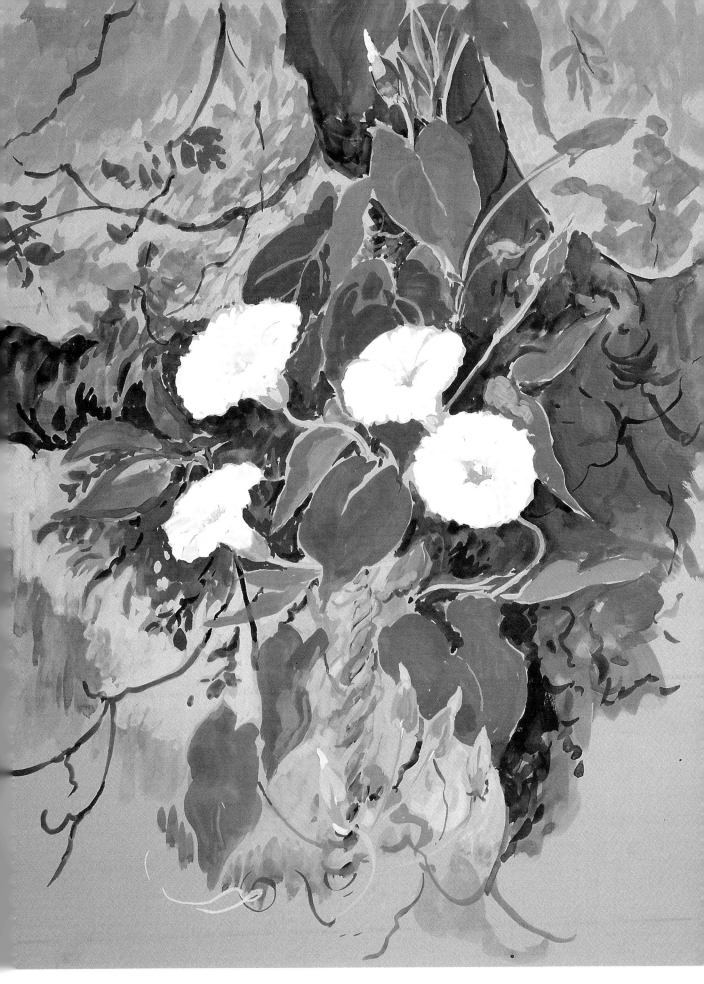

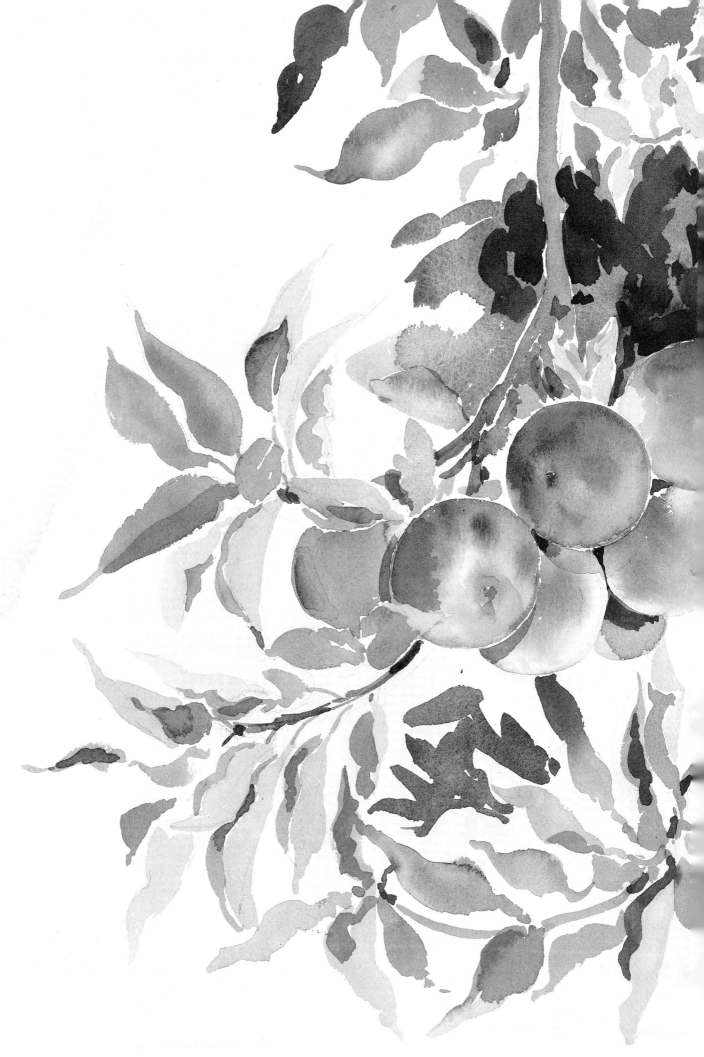

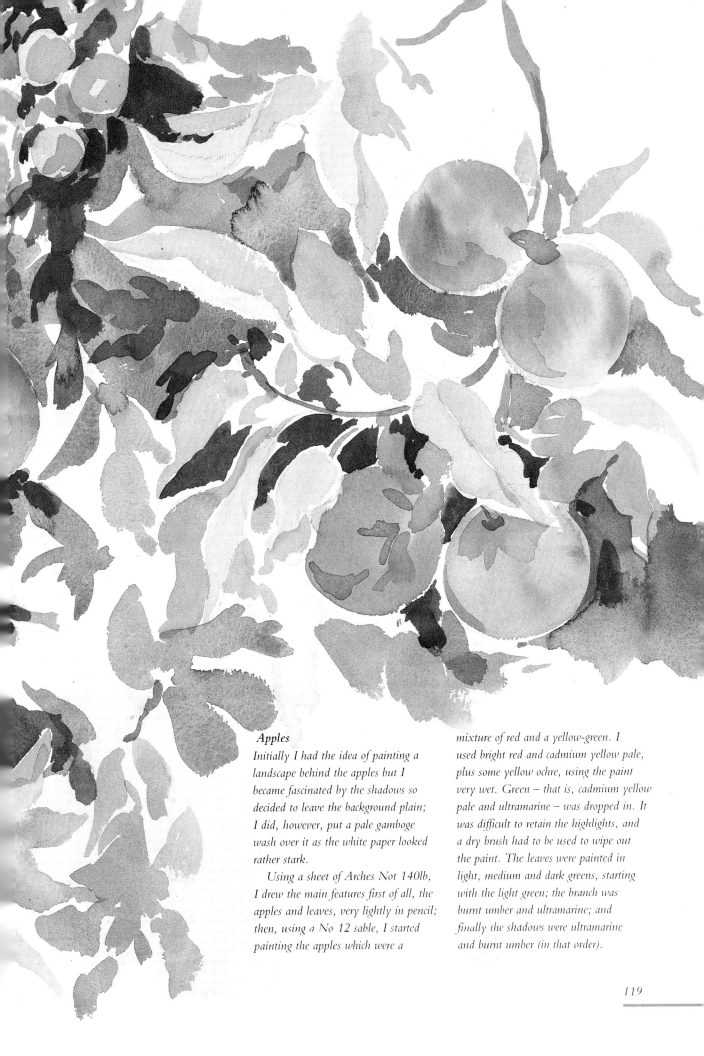

Apples

Initially I had the idea of painting a
landscape behind the apples but I
became fascinated by the shadows so
decided to leave the background plain;
I did, however, put a pale gamboge
wash over it as the white paper looked
rather stark.

Using a sheet of Arches Not 140lb,
I drew the main features first of all, the
apples and leaves, very lightly in pencil;
then, using a No 12 sable, I started
painting the apples which were a
mixture of red and a yellow-green. I
used bright red and cadmium yellow pale,
plus some yellow ochre, using the paint
very wet. Green – that is, cadmium yellow
pale and ultramarine – was dropped in. It
was difficult to retain the highlights, and
a dry brush had to be used to wipe out
the paint. The leaves were painted in
light, medium and dark greens, starting
with the light green; the branch was
burnt umber and ultramarine; and
finally the shadows were ultramarine
and burnt umber (in that order).

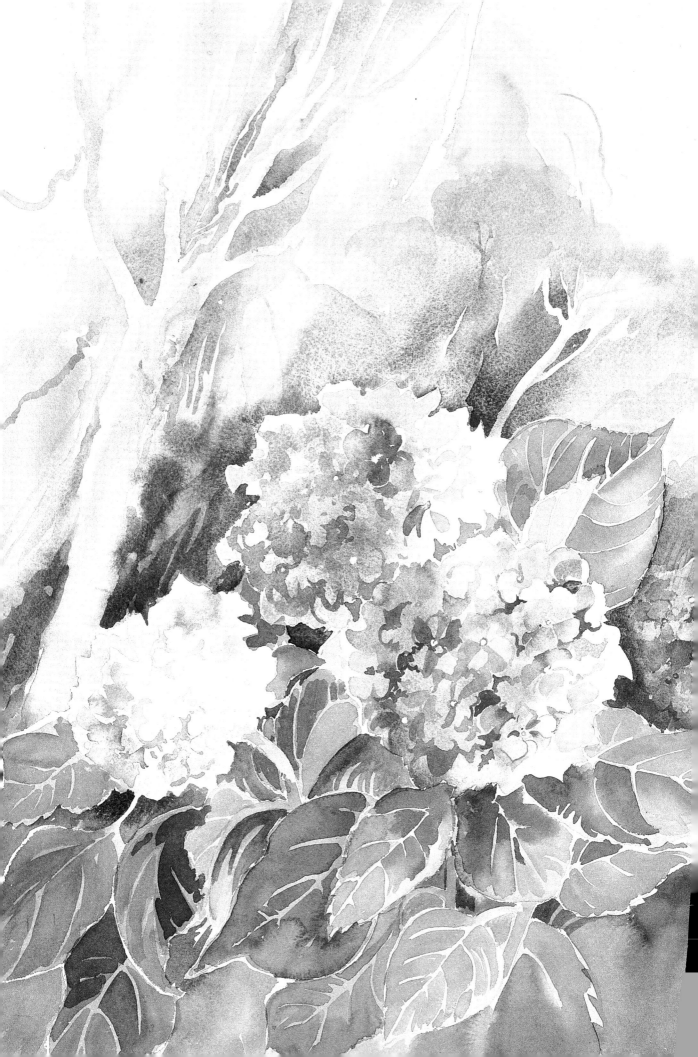

Hydrangeas

Hydrangeas seem to be with us for most of the year, and the flowers can be pink, blue, green, red, or white in the most subtle mixture of tints and shades. The mass of flowers in the heads calls for a broad approach. My original painting could have been taken further, but I decided on a landscape background and started again. The finished painting (left) on Whatman paper was started on a dampened surface. I placed the flower-heads first, dropping in a mix of blues: first cobalt, then ultramarine, then cerulean, but letting the mixing happen on the paper. The blue of the flowers was vibrant it is only too easy to let your paint be too pale, and then have it dry even paler.

While this was drying, I indicated the leaves in a pale green. Other parts of the painting were next, starting with the pale sky and the grey distant trees; the whole area was allowed to dry before continuing. Then I worked on the flower-heads; it is often difficult to decide how much to put in and how much to leave out, but I felt that the individual flowerets needed some definition.

The leaves were large and decorative, and only seemed to need a further tone on them, leaving the background colour as veins. I was really rather indecisive regarding my landscape background; I had bought the hydrangeas in a pot and put them against the window, and as it was winter the grey trees outside formed the background: it was this I decided to paint, and tried to convey the mysterious feeling of a grey November day.

(Previous page) **Trial sketch**
The trial sketch certainly clarified my thoughts as to approach – although it seemed a long-winded way to go about painting these rather special flowers. I was glad to have made it; I could probably have gone on to finish that too, but decided to tackle other hydrangeas which were drying, as I find the colours irresistible. So I have another subject stored up and waiting!

123

Materials and Organization

Materials

As we have worked our way through this book you will have realized that there are certain materials which are essential, and others which, while being nice to possess, are not so necessary. Artists will always vary as to which colours to have, and your palette will be built up from your own experience, as will paper and brushes. (You could start with one brush, one colour and a sketch-book, but without guidance of some sort this is hard advice to follow.)

I will list the equipment that I consider essential, most of which I keep in my bag (with the exception of the drawing board and large sheets of paper), so that I can be ready at short notice to go out and paint that ever-elusive masterpiece.

Contents of my Sketching Bag

A palette for mixing colour, and a small sponge.
Two water pots, and bottle for containing water.
Paints, brushes, pencils and some clips.
A sketch-book for taking notes.
Drawing board 16 × 25in (40.5 × 63.5cm) to support half sheets of paper, and strong enough to stretch paper on without bending. (I carry my drawing board and paper separately.)

Of course, when working outside you will not perhaps have the entire contents of the studio with you, and there will be some items that you omit – it really is advisable to be lightweight and fresh for painting so your work will be of the best possible quality.

As well as these items in your bag, you will need an easel and a lightweight stool.

Pencils and pens

If you like to draw before painting, use a soft pencil, a 2B or 3B, but draw with a light touch, as heavy marks are difficult to erase. You will need a soft or putty rubber for erasing.

I prefer a pen with a separate nib and Indian ink, but there are many types of pen to choose from, both non-waterproof and waterproof; all need to be practised with, and perform best on a smooth paper. A sharp knife is always useful, as are clips and tape.

Brushes

I separate my watercolour brushes from the gouache brushes, but the requirements are the same. Sable are the best, but expensive. I use a No 12, a No 8 and a No 5 for watercolour and these meet all my requirements, but I also possess two flat brushes and other odds and ends which may come in useful.

Paper

Paper is available in many forms: pads, blocks and sheets. I tend to use sheets, as in the long run this is cheaper, but have found a use for smaller sketch-books which fit in my bag. I use 140lb weight or upwards, and vary between Bockingford (good for beginners), Arches and Saunders. Occasionally I use a rough surface, but for any detail Not (Cold Pressed) is ideal. Any paper under 140lb should really be stretched, as it will cockle.

Stretching Paper

This is necessary for lightweight paper. Immerse the paper in water (a bath or sink), take it out and fix it to your board with strips of tape – use a gummed paper tape, *not* masking tape – remove excess moisture and leave to dry. (Leave the paper on the board until your painting is finished, then remove it with a sharp knife.)

Paints

Squeezing tube colour into my palette works well, and I use artist's quality. However, note that palettes often take half or full pans, according to size; this is a matter of personal choice, but it is as well always to have deep wells for mixing colour, and perhaps a supplementary plate for extra use. Two plastic waterpots are useful, one for clean water, and a leak-proof bottle, plus a small sponge, and some blotting paper or tissue.

Palettes

There are a great many palettes available, and it is advisable to opt for a good – that is, expensive – one, as I have known palettes to chip and rust badly. Some of the larger plastic palettes also tend to split and need some sort

of cover. I like a palette to hold my tube colour squeezed out, and really as much space as possible is needed for washes. Working at home is easier, as you can utilize plates and saucers for large washes; but going out, you need to be lightweight, particularly if you use the thumb-hole in a palette. Too heavy a palette and your thumb will need a splint!

Try not to mix watercolour and gouache on the same palette; keep them separate if you can, as gouache will dirty the watercolour. Always keep your palette clean!

Colour

This is a list of essential colours I use, plus additions:

Yellow ochre	Brown madder
Cadmium yellow pale	Crimson alizarin
Burnt sienna	Prussian blue
Burnt umber	Ultramarine

Useful additions:
Raw sienna
Raw umber
Hooker's green
Indigo
Cobalt
Cerulean

Good for flowers:
Magenta
Permanent rose
Rose madder genuine
Cadmium orange
Winsor violet
Winsor yellow
Lemon yellow
Gamboge
Aureolin
Viridian

There are many other colours you *could* have – Payne's grey is one!

Gouache

I use a separate palette and brushes for my gouache paints, and the colours I use are:

White	Ultramarine
Spectrum yellow	Winsor green
Lemon yellow	Chrome green
Raw sienna	Burnt sienna
Yellow ochre	Carmine
Sky blue	Flame red

I often paint in gouache on tinted Ingres board, sand, grey or green, as well as on white paper.

These are just a few of the materials I use – tube colours, pencils, a palette with plenty of space for mixing paint, and some brushes. You will find that you will build up your own materials with experience; all artists have their own preferences.

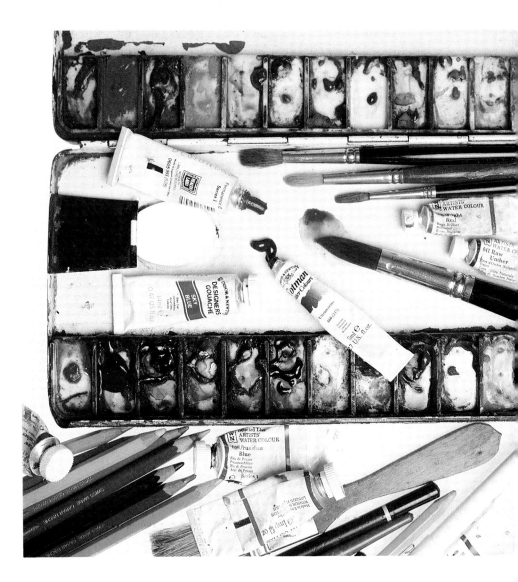

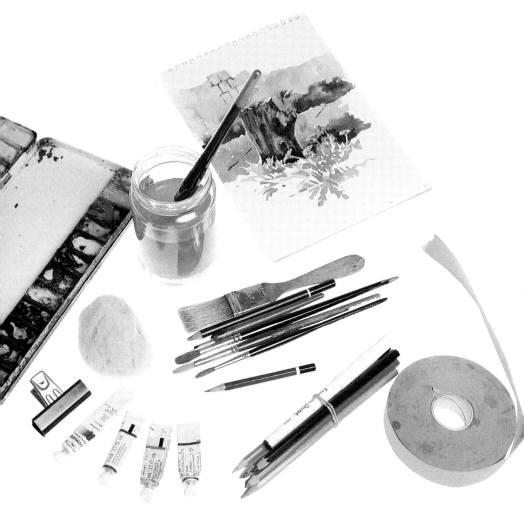

Other useful equipment:

A natural sponge
Blotting paper
Tissues or kitchen paper
Masking tape
Clips
Ruler
Black conté pencil
A camera
Sketch-book
A cap with a peak (a baseball cap is ideal)
Fly repellent

This reads like a holiday list; but if you haven't got it, you are bound to need it.

Water-soluble Coloured Pencils

These can be used on watercolour paper, but a smooth paper is preferable. If you are going to use a lot of washes, the same advice for watercolour paper is advisable. I possess about twenty pencils, but there are many more colours and tints available; I would tend to choose the basic colours and then go on to a few of the more exotic ones, such as pinks and mauves. It is essential to have a good pencil sharpener, as it is most important to keep pencils well sharpened.

Working Practice

Artists often work in a solitary way, so sometimes it is pleasant to go painting with a friend and be able to exchange views; and it is especially gratifying if they appreciate your work! If you want to enlarge your painting experience, it would be a good idea to join a club and maybe go to classes; you would probably have

The Cornfield
The edges of fields are always intriguing – you never know what you will find. In this case, it was dandelion clocks, poppy seed heads and escaped corn forming an L-shaped composition with grasses breaking the line, and the vertical stalks and round 'clocks' providing the focus. I am always attracted to counterchange and keep it constantly in mind; the light shapes interacting with the dark, and vice versa.

the chance to exhibit your work, and to see it hanging alongside others. Local clubs often have yearly exhibitions, and the experience of framing two or three paintings is valuable. However, before you embark on framing, which is expensive, visit exhibitions and look at the ways in which paintings are presented; note the frames and mounts, because if you are a practical person there are several different ways of doing the framing yourself. To frame a painting requires moulding, glass, the mount, the painting itself and a backing board.

The choice of mouldings is extensive, and it is often hard to make decisions as to style. If you are going to make your own frames, there are books and classes to help you. You can have the various parts made, or cut and assemble them yourself, or you can buy easily assembled frames; there are many ways to go about it.

Do try to present your work in the best way possible. This means keeping it clean and tidy, with trimmed edges, perhaps in a portfolio which keep your paintings clean. A steel rule is always worth having, together with a sharp blade.

Conclusion

Painting can be fun; it is all-absorbing, it is creative, it is something you can do on your own or with painting friends, it creates a bond, and it is an occupation which spans all ages. You can be as light-hearted or as serious as you like. You can practise painting almost anywhere, in a room or out of doors, and apart from certain essential materials, it need not cost too much. You can paint at any time of the year or day, and the passing of the seasons can only add variety and interest.

You have to be prepared to work hard to improve, and to be receptive to different approaches and new ideas; to be observant in every way, and not only to practical painting methods; and to be willing to develop yourself, too.

Enthusiasm and excitement are important in carrying your work through from start to finish. I hope that some of the ideas in this book will help you, not only to start painting, but to continue, and that painting, which is such a constant pleasure for me, will be so for you as well.

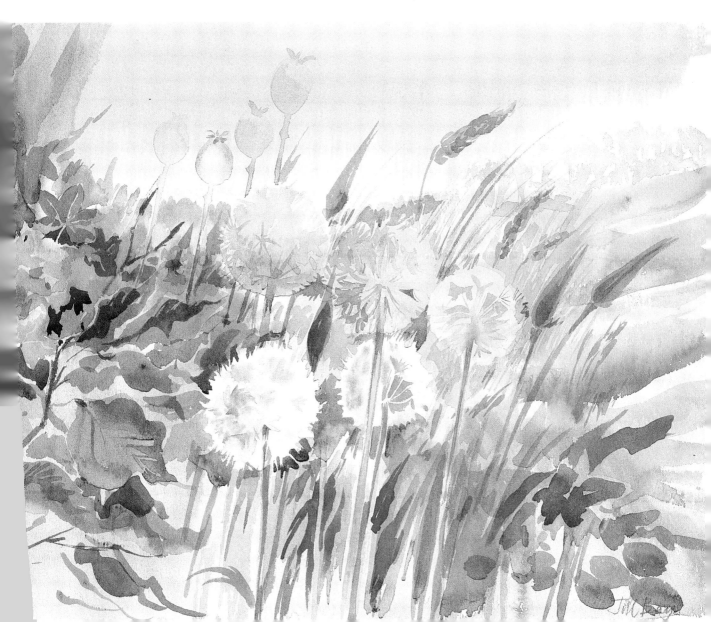

Index